A
BEAUTIFUL
GHETTO

A
BEAUTIFUL
GHETTO

Devin Allen

Haymarket Books
Chicago, Illinois

Published by
Haymarket Books
P.O. Box 180165
Chicago, IL
www.haymarketbooks.org

ISBN: 978-1-60846-759-4

Trade distribution:
In the US through Consortium Book Sales and Distribution, www.cbsd.com
In the UK, Turnaround Publisher Services, www.turnaround-uk.com
In Canada, Publishers Group Canada, www.pgcbooks.ca
All other countries, Ingram Publisher Services International, intlsales@perseusbooks.com

This book was published with the generous support
of the Wallace Action Fund and Lannan Foundation.

Design by Eric Kerl.

Printed in Canada by union labor.

Library of Congress CIP Data is available.

10 9 8 7 6 5 4 3 2

FREDDIE GRAY'S BALTIMORE

Devin Allen and only Devin Allen documented what would come to be known as the "Baltimore Uprising." With his unerring eye and impeccable skill, Devin created more than a series of photos; he gave us gifts. Gifts you can't put a price on—beautiful images that conquered the false narratives produced by multiple media outlets, humanized the broken and misrepresented residents of Baltimore, and truly honored the life and legacy of Freddie Gray. Because of Devin Allen's work, Freddie Gray can and will live forever.

ANOTHER NIGHT, 2012

Years before my résumé said "*New York Times* Bestseller," years before Rihanna was posting BYDVNLLN photos, and definitely before we both got love from companies owned by Oprah, I met this artist.

That night, I hit a bar to self-medicate after a bad round of edits in my writing class—two shots of rail vodka went down quick; the next round stared at me while a tall double of whisky sat parallel to my order in front of the skinny dude with the bushy eyebrows just a few chairs down. He kicked off a conversation as more and more shots followed—our topics shifted from politics to sports back to politics before escalating to shouts of "I'm from West Baldamore!" by that artist Devin Allen against my "I'm from East Baldamore!"

We laughed and joked in that universal Baltimore way—you know, just loud enough to make every white person in the room uncomfortable, not loud enough to be kicked out. I was hooked on the idea of becoming a great writer at the time, and Devin was a retiring poet just getting into photography.

Our friendship was birthed that night. Like Devin, I constantly worked on my craft, every day, and I watched his photos go from basic Instagram posts with his *Moo Lo* tag stamp to some of the best images I'd ever seen in my life. No one—and I mean no one—captured nature, beauty, and life like Devin. He should never be referred to as an overnight success story; over the years Devin honed his skills every day, in the studio, in the streets, in abandoned buildings, and even in the club— you couldn't catch Devin without a camera.

APRIL 12, 2015

People close to Freddie Gray referred to him as a jokester, a nice guy whom everyone loved and wanted to be around. On that April Sunday, the same nice guy everyone loved was illegally approached by a group of rogue police officers.

Initially he ran, like a lot of Black men do when we see cops, because for our generation, police officers have been the most consistent terrorists in our neighborhoods. Plus, we live in a culture where cops kill African Americans with their hands up like Michael Brown, if they follow directions like Philando Castile, or if they are wearing cuffs like Oscar Grant—I swear they see Black skin and think *murder*.

The Baltimore City Police Department officers pursued Gray in traditional bully fashion, caught him, found a legal pocketknife, beat him, and arrested him for no reason. Who knew that running with a pocketknife is against the law in Baltimore? Once they got Gray into the van, he was taken on what we call a "nickel ride," which is basically when cops throw a suspect in the paddy wagon

without securing them and drive crazy until they reach the police station.

The cops who arrested Gray took it to another level, severing his spinal cord and smashing his voice box in the process. Police officers are supposed to follow the guidelines offerred by the Red Cross and National Institutes of Health: "Do not bend, twist or lift the person's head or body, do not attempt to move the person before medical help arrives unless it is absolutely necessary and do not remove any clothing if a spinal injury is suspected." Gray asked for help before entering the van, but he was denied—the arresting officers violently dragged his limp limbs across the pavement, which probably caused further damage to his spinal column.

APRIL 19, 2015

As a result of their negligent behavior, Gray died in the hospital days later. His death was attributed to multiple spinal cord injuries. Gray's murder sparked a series of peaceful protests and demonstrations.

APRIL 25, 2015

A group of protesters marched down to the Inner Harbor, chanting, "No justice! No peace!" The marchers were greeted by drunken Orioles and Red Sox fans who yelled, "We don't care! We don't care!" The two groups clashed as Devin, along with a string of other photographers, went to work. The difference between him and the other photographers is that Devin is Black and from the ghetto—he has run the streets under multiple capacities, from dealer to concerned citizen, and experienced racism in a way that his white counterparts could never understand. Those people out marching for Gray's justice weren't career activists or professional protestors—no, they were hurt, disenfranchised Black people who constantly feel robbed by the system, just like Devin Allen. Devin's role was more than that of a photographer, he was a liaison between *his* people and the rest of the world, and you can feel the compassion in his photos. They aren't cheap and exploitative; they capture the love, pain, togetherness, and humanity that exist within the Black community—what he calls *A Beautiful Ghetto*.

To date, those images, many of which are iconic now, have taken Devin, a self-trained photographer from West Baltimore, around the world, providing him with opportunities most artists could only dream of—shows in Italy, shoots in China, lectures at Ivy League universities, and multiple fellowships, including the inaugural Gordon Parks Fellowship. But Devin isn't like most artists—sure, he sees the value in travel, but he never even considered any opportunity that required him to move away from West Baltimore, and that's why he is a real hero.

Devin doesn't use his fame and success as a shield to separate himself from his origins but as a tool to uplift people with backgrounds similar to his, by collecting hundreds of cameras and giving away lessons and shows to future Devin Allens all over Baltimore. Devin lives and works in the community that raised him and uses his connections and skills to expose young people to the redemptive power of art—and that's how you prevent the next Freddie Gray from happening. As a child, Devin never had famous local photographers to look up to, and now he's that person for so many young people. For that, we thank him.

The world needs more Devin Allens.

D. WATKINS is the author of *The Cook Up: A Crack Rock Memoir.*

THE BOISTEROUS DEMAND OF BLACK BALTIMORE

In the spring of 2015, an urban uprising in the city of Baltimore ruptured an uneasy quiet across the country that many mistook for calm. It had been eight months since a rebellion in Ferguson, Missouri, had brought international attention to the scourge of political abuse and violence in the lives of African Americans. In the news media and among the political establishment, there was talk about the peculiarity of Ferguson. It was the suburb that time had forgotten, with its white municipal authorities lording their power and authority over its largely Black population. Ferguson was portrayed as a throwback to the bad old days of Jim Crow racism and political corruption. Ferguson inspired a national movement as once again, a young Black victim of police and judicial misconduct was portrayed as an aggressor and perpetrator and responsible for his own death. But by the early spring of 2015, it was unclear where the new Black Lives Matter movement was going. Endless meetings with public officials only seemed to produce more meetings with other officials, and all the while Black people and many others continued to be killed and abused in the streets of the country. One of those victims was Freddie Gray.

Freddie Gray was a young, twenty-five-year-old Black man from West Baltimore. The police arrested him for running away from them. As punishment, Gray was placed in the back of a police van with no seat belt to restrain his body, leaving him to career violently against the walls of the van as it was driven around West Baltimore. By the time Freddie Gray exited the van, his spinal cord had been 80 percent severed. He slipped into a coma, never to wake again; one week later he died from his injuries. Ordinarily, Freddie Gray would have become another unknown victim of the racism, inequality, and brutality that animates so much of American society. Instead, his death ignited an uprising that pierced the illusion that *something* was happening to address the epidemic of police violence and abuse across the nation. By the spring of 2015, marches and protests against police brutality were giving way to roundtables at the White House, slow-paced investigations, and costly commissions. Gray's death was a terse reminder that the pace of police killings continued unabated.

Ferguson had been treated as an exception, but Baltimore exposed systemic—as opposed to superficial or exceptional—injustice and inequality. Here was a city barely forty miles from our nation's capital, where the nation's first Black president sat as the most powerful figure in the world. Where Ferguson's Black population endured the predatory harassment of police and elected officials, Black people were in power in Baltimore. From the mayor to the chief of police, African Americans held powerful positions across city government in Baltimore. Indeed, three of the six police officers indicted for the murder of Freddie Gray were African American. But Baltimore came to sharply symbolize how the financial and political success of some African Americans could not be assumed for all African Americans. Despite the ascension of some "Black faces in high places," tens of thousands of Black people in Baltimore lived a life of hardship.

The bitterness and anger at that hardship boiled over with the murder of Freddie Gray. When protests escalated into an uprising, public officials, including president Barack Obama and mayor Stephanie Rawlings-Blake, described the young people at the heart of the rebellion as "thugs." Media obsessions with buildings burned and looted, cars set ablaze, and millions of dollars of property damage resulted in presumptuous condemnations of "senseless" or "mindless" violence exemplified by the awful question, "Why are they burning down their own community?" The Baltimore Uprising was not, however, "senseless." It was the boisterous demand of the Baltimorean Black working class and poor to be heard and seen after decades of being rendered invisible. As author Arundhati Roy has written, "There's really no such thing as the 'voiceless.' There are only the deliberately silenced, or the preferably unheard."

Rebellions are always surprising in American society because segregation hides Black life from white America. Just as urban uprisings in the 1960s brought the awful racism and injustice faced by Black America to the surface of American society, Ferguson and Baltimore had the same effect. But in the rush to understand or report on "how could this happen," the media and political establishment flatten and deaden the vibrancy and complexity of Black life. This was certainly the case in Baltimore. Black Baltimore, with its long history, has instead been suffocated by mind-numbing statistics cataloguing poverty, lead poisoning, homicides, and unemployment. These, of course, can be important markers in attempts to chart the public and private institutional underpinnings of the social crises in communities across Baltimore, but they are often highlighted at the expense of locating the humor, beauty, history, community, and humanness of Black Baltimore. In this sense, Devin Allen is a gift.

A Beautiful Ghetto intervenes in a longstanding debate about how we understand and discuss Black life in the United States. In the endless search for "root causes" to Black inequality, there has been an avalanche of facts documenting the effects of "the ghetto," segregation, and the consequences of that kind of spatial isolation. Liberalism and conservatism often converge at the point of erasing the individuality and humanity of Black people by invoking the perils of "the ghetto." But what is often missed is what Black people have done within that space. Indeed, Devin Allen captures what can be referred to as Black "placemaking." Black life is not only about hardship, it is also about poetry, play, celebration, curiosity, tradition, and what some have referred to as "the beautiful struggle." Where some see only a "ghetto," we have often seen the "Black Metropolis," or our space where we share—across cities and regions—language, music, food, and a common history of resistance and struggle. Of course, it is also a space animated by class tensions and typical quarrelsomeness, but it is so much more interesting than the dark, drab dystopia described by social scientists and president Donald Trump.

Devin Allen's perceptive and sensitive eye has captured these processes of community in Baltimore, but it is a visual narrative that could tell the story of a thousand Black communities across the United States. From the barbershop to the corner to the introspection captured on the faces of the neighborhood youth, Allen's camera brings his unique portraiture to life and contributes a perspective on the Baltimore Uprising that has been rendered nowhere else. In doing so, he gives deeper meaning to the movement slogan "Black Lives Matter."

KEEANGA-YAMAHTTA TAYLOR is a professor of African American studies at Princeton University and the author of *From #BlackLivesMatter to Black Liberation*.

THE FREDDIE WE NEVER KNEW

I write this not just as Devin's friend, who roots for his success daily. I write this not just as a Baltimorean who loves this city and believes in its promise. I write this not just as a Black man, someone who doesn't just sympathize but empathizes with the reality of inequality that still exists within our society. I write this not just as a youth activist, someone who through his work in education and poverty alleviation understands that an honest conversation does not happen unless it is an inclusive conversation. I write this not only as a husband and a father who understands that my daughter is my heart, my son is my soul, and my wife is my everything. I write this as an amalgamation of all these things. And I write this with all my heart.

Devin's work is truly important.

I admire it because many people understand the story of Freddie Gray as an aftermath. We understand and we talk about the conclusion. We look at and we examine this incident through the illustration of his death. We all know the story and our hearts break over what happened on the day he lost his life. A young man in his own neighborhood makes eye contact with law enforcement and begins to run. A short time later he is in handcuffs and arrested. A video captures him being dragged and pulled into the back of a police van. Screaming and obviously in pain. An hour later, the same young man was in a coma. And a week after falling into a coma he was dead.

So much of the focus on Freddie circled around his death, and rightfully so. How can someone simply die and there be no accountability for it? What so many of us have tried to do, what Devin and his work ask us to do, is to not simply understand his death but to do a better job of trying to understand his life. Not simply to mourn his death but to also mourn his life. Mourn the fact that this was a man who was poisoned by lead as a child, a young man who was living in a place that was literally making him sick. Mourn the fact that this was a young man who was years away from a high school degree and who seemed as disinterested in school as school was disinterested in him. Mourn the fact that this was a young man who never held a full-time job for any real period of time, who bounced from employment opportunity to employment opportunity. Mourn the fact that this was a young man whom the arresting police officers knew on a first-name basis.

We ask that we all collectively know his name. Not just his name in death but know his name in life. To celebrate the resilience and the beauty in our communities and our ability to appreciate our roses in the concrete. Celebrate our ability to appreciate the fact that what each person wants more than anything else is simply to be noticed, to be recognized. That each person wants to be seen as an asset to be utilized and not necessarily as a problem to be solved. We will never get to the point we want to get to in our community if we look at it from a paternalistic standpoint—our inclusive work and the celebration of our basic genius matters.

I know Devin, his heart, and his work. We don't celebrate each other because we have to. We celebrate each other because we need to. Because Baltimore, and the narrative around Baltimore, has to be written by us, embraced by us, and shifted by us. Gone are the days when we can allow others to tell us who we are, particularly without a

response. Our art. Our culture. Our people. Our communities. Our teachers. Our community leaders. Our parents. Our entrepreneurs. Our activists. Our graduates. These are people who make us proud to be from this place we call home. Our work remains consistent and true. Celebrate and understand life, so we don't have to spend all our time mourning death. See Devin's work and understand its impact and the souls on both sides of the lens.

WES MOORE is CEO of Robin Hood, founder of BridgeEdU, and bestselling author of *The Other Wes Moore* and *The Work*.

CRITIQUE, PICTURES, AND PROGRESS

DEVIN ALLEN AS SOCIAL CRITIC

> Certain conditions continue to exist in our society which must be condemned as vigorously as we condemn riots. But in the final analysis, a riot is the language of the unheard.
>
> **—Martin Luther King Jr., "The Other America," 1967**[1]

On Sunday, April 19, 2015, Freddie Gray, a twenty-five-year-old Baltimore man, died from injuries he suffered during an arrest made by Baltimore City police a week earlier. Initially, there was peaceful protest following Gray's encounter with officers, but incidents of confrontation overshadowed peace following the news of Gray's death. By April 27, the day of Freddie Gray's funeral, fires and rebellion had spread throughout the city and communities in Baltimore were in revolt. Devin Allen had been shooting photographs for only two years when his images of protest went viral via the Internet. Seemingly overnight, the self-taught photographer became a global wunderkind, and, weeks after the initial uprisings in Baltimore, one of Allen's images made the cover of *Time* magazine. This would be an honor for any photographer at any stage in their career. The iconic photograph that captured the world's attention was the image of a man, who masked himself with a cap and bandana, as he ran away from a charging line of police officers in riot gear. According to Allen, he shot the image on How-

ard Street in Baltimore. It was the center of protests, and Allen's photograph documents a critical flashpoint in the conflict that arose after Gray's death.

At such a young age, Devin Allen has an eye for the formal qualities of well-crafted photography. His ability to create emotional and compositional tension through the correct placement of lines, angles, shapes, and forms is uncommon for someone so new to the field. Additionally, Allen has a rare instinct for scale and proportion, as he perfectly frames his images even as his subjects are moving. He intuitively understands the ways in which his camera creates compositional layers and dimensions through manipulating the image's tones, textures, patterns, and colors. In addition to his artistic instincts, Allen is a humanitarian and an activist whose advocacy informs his art. Visually documenting the everyday lives and cultures of communities, Allen is a social critic and ethnographer who sees himself as part of the cultures he portrays.

In this way, Devin Allen might be seen as an inheritor of legacies pioneered by artists like Gordon Parks. Parks saw photography as a weapon against social inequities. As the photographer once wrote, remembering his image of Ella Watson standing in front of the American flag,

1. Martin Luther King Jr., "The Other America," speech delivered at Stanford University, April 14, 1967, p. 4, www.auroraforum. stanford.edu/files/transcripts/Aurora_Forum_Transcript_ Martin_Luther_King_The_Other_America_Speech_at_ Stanford_04.15.07.pdf.

"I have known poverty firsthand, but there I had learned how to fight its evil—along with the evil of racism—with a camera."[2] Gordon Parks photographed Watson in 1942, while working for the Farm Security Administration (FSA). He went on to publish a series of photographic essays on race and poverty for *Life* magazine in later years, and often referred to his camera as a tool in the fight against racial discrimination and economic injustice. In 1948, Parks published a photo essay on Red Jackson, the teenage leader of the Midtowners gang in Harlem. In 1961, he published a visual chronicle of Flavio da Silva and his family in the favelas of Rio de Janeiro. In 1963, Parks published a series on the Nation of Islam for *Life*, with the title "The White Man's Day Is Almost Over," and in 1968, the photographer published "A Harlem Family," a photo essay on poverty and the Fontenelle family in New York. *Life* titled that particular issue of the magazine "The Negro and the Cities: The Cry That Will Be Heard," which is conceivably a reference to Martin Luther King Jr.'s assertion that inner-city riots were "the language of the unheard." It becomes easy, therefore, to see how Devin Allen might be considered a Gordon Parks for a twenty-first-century generation, when comparing the intent and social commentaries of the photographers.

While Gordon Parks used *Life* magazine to share his message, however, Devin Allen reaches communities through the immediacy of social media. Similar to the ways in which the civil rights movement made images public through print and broadcast news, Allen circulates his hybrid of photojournalism and street photography through the free and open democracy of the Internet. Crafting art that is by, for, and about the people, Allen blends an urban vibe of millennial hip-hop with the Black Power soul and human rights zeitgeist of the 1960s. Through photography, Devin Allen captures the voice, agency, and self-awareness of a community to reflect a distinct understanding of the people he portrays. In documenting Baltimore's uprisings, for example, he takes us beyond the two-dimensionality of images to portray the tangible tensions of confrontation and protest. He also captures joy through portraits of communities that have mobilized to create positive change.

Sadly, however, Allen's insightful visual commentaries on riots, poverty, and rebellion are not unlike the observations made by community leaders and government commissions more than fifty years ago. On April 14, 1967, for example, Martin Luther King Jr. delivered an address at Stanford University entitled "The Other America." In his speech, King outlined what he believed to be the catalysts to a surge in civil unrest across the country. While advocating peaceful protest as the best way to achieve social change and justice, King also spoke out against the institutionalized racism and discriminatory policy practices that fueled anger and frustrations in poor communities of color. As the civil rights leader explained, "Large segments of white society are more concerned about tranquility and the status quo than about justice, equality, and humanity. And so in a real sense our nation's summers of riots are caused by our nation's winters of delay." King continued, "And as long as America postpones justice, we stand in the position of having these recurrences of violence and riots over and over again." For King, achieving the American promise of justice and social equality was the best means of preventing civil unrest.[3] As the civil rights leader predicted, months following his Stanford speech, large-scale rebellions erupted in cities nationwide, including Newark, New Jersey, and Detroit, Michigan. Reportedly, in Newark, twenty-six people died during several days of riots. Eleven hundred people suffered injuries, fourteen hundred were arrested, and three hundred and fifty fires burned.[4] In Detroit, forty-three people were killed. Over one thousand people were injured, and thirty-eight hundred people were arrested. By

2. Gordon Parks, *To Smile in Autumn: A Memoir* (Minneapolis: University of Minnesota Press, 2009), 24.

3. King, "The Other America," 7.
4. Kevin Mumford, *Newark: A History of Race, Rights, and Riots in America*, (New York: New York University Press, 2007), 125.

the time the smoke settled in Motor City, one thousand buildings had burned.[5]

In response, president Lyndon Johnson signed Executive Order No. 11365 to establish the National Advisory Commission on Civil Disorders, on July 29, 1967.[6] Comprised of eleven people appointed by the president, Johnson charged the commission with investigating the rise in civil unrest to offer insights on three primary questions: What happened during the riots? Why did the riots occur? What could be done to prevent uprisings from happening in the future?[7] Governor Otto Kerner of Illinois chaired the committee that eventually assumed his name, and the National Advisory Commission on Civil Disorders became known informally as the Kerner Commission. In addition to Newark and Detroit, the group surveyed riots in twenty-three cities, including Tampa, Cincinnati, Atlanta, and New Brunswick.

On August 15, two weeks after Johnson launched his commission, King delivered another speech on urban rebellion at the tenth annual Southern Christian Leadership Conference (SCLC) convention in Atlanta. Entitled "The Crisis in America's Cities," King's address signaled his growing militancy and frustration with economic inequality, as his social justice platform evolved into an economic and human rights agenda. "When we ask Negroes to abide by the law," King demanded,

let us also declare that the white man does not abide by the law in the ghettos. Day in and day out he violates welfare laws to deprive the poor of their meager allotments; he flagrantly violates building codes and regulations; his police make a mockery of law; he violates laws on equal employment and education and the provisions for civic services. The slums are the handiwork of a vicious system of the white society; Negroes live in them but do not make them any more than a prisoner makes a prison.[8]

Weeks later, when the Kerner Commission submitted its final report to President Johnson in March 1968, the committee came to similar conclusions as the civil rights leader.

According to the commission's report, during the summer of 1967, nearly one hundred and fifty cities experienced uprisings ranging from minor disturbances to major rebellions, and based on its analysis, the commission concluded that the country was racially, as well as socially and economically, divided.[9] "Our nation is moving toward two societies," the group reported, "one black, one white—separate and unequal."[10] Additionally, the Kerner Commission identified several common grievances among residents living in the twenty-three cities surveyed. These grievances from fifty years ago are eerily similar to the grievances raised by communities today. First, in the Kerner Commission's survey, there were complaints against law enforcement and policing practices, as well as grievances regarding inadequate housing, unemployment, and underemployment. Second, residents were frustrated with the lack of access to quality education, recreational facilities, and neighborhood programs for

5. Joe T. Darden and Richard W. Thomas, *Detroit: Race Riots, Racial Conflicts, and Efforts to Bridge the Racial Divide*, (East Lansing, MI: Michigan State University Press, 2013), 1.

6. Lyndon B. Johnson: "Remarks of the President upon Issuing an Executive Order Establishing a National Advisory Commission on Civil Disorders," July 29, 1967, box 243, Civil and Racial Disturbances and the Commissions on Civil Disorders and Violence; Statements of Lyndon B. Johnson, Lyndon Baines Johnson Presidential Library, Austin, TX; National Advisory Commission on Civil Disorders, *Report of the National Advisory Commission on Civil Disorders*, (New York: Bantam Books, 1968), 534–538.

7. National Advisory Commission on Civil Disorders, 1.

8. Martin Luther King Jr., "'The Crisis in America's Cities': An Analysis of Social Disorder and a Plan of Action Against Poverty, Discrimination and Racism in Urban America," speech delivered at the Tenth Annual Southern Christian Leadership Conference Convention, Atlanta, Georgia, August 15, 1967, p. 1, www.thekingcenter.org/archive/document/crisis-americas-cities.

9. National Advisory Commission on Civil Disorders, 32.

10. Ibid., 1.

children. Additionally, mechanisms for filing and addressing grievances were inadequate and ineffective. Finally, residents cited discrimination in the justice system, discriminatory consumer and credit practices, inadequate public assistance programs, and disregard for communities of color.[11] Both King and the Kerner Commission separately found that economic inequalities and lack of opportunities fueled the frustrations that ultimately led to riots.

"It's something that is often overlooked, but Negroes generally live in worse slums today than twenty or twenty-five years ago," King said at Stanford. "In the North schools are more segregated today than they were in 1954 when the Supreme Court's decision on desegregation was rendered. Economically," King continued, "the Negro is worse off today than he was fifteen and twenty years ago. And so the unemployment rate among Whites at one time was about the same as the unemployment rate among Negroes. But today," King concluded, "the unemployment rate among Negroes is twice that of Whites. And the average income of the Negro is today 50 percent less than Whites."[12]

Similar disparities exist today. As CNN observed in 2015, which was the year of Baltimore's uprisings, Baltimore is in the richest state in the country. However, a comparison of median incomes for Maryland to the median incomes of African Americans in Baltimore shows a difference of nearly $40,000 a year in earnings. Further, while whites in Baltimore have a median household income of $60,550, the median income for African Americans is nearly half,

at $33,610 a year.[13] Additionally, CNN reported that the unemployment rate for African American men between the ages of twenty and twenty-four in Baltimore was 37 percent in 2013, compared to 10 percent for white men in the same age bracket. *Time* magazine's cover of Devin Allen's image for their May 11, 2015, issue, therefore, was making an important statement and critical observation. As King stated in 1967, a year before his assassination, "in the final analysis, a riot is the language of the unheard. And what is it that America has failed to hear? It has failed to hear that the plight of the Negro poor has worsened over the last few years. It has failed to hear that the promises of freedom and justice have not been met."[14]

Devin Allen makes analogous observations and comparable insights through his photography. His images confront us with what might be seen as evidence of the effects of legislation and policies that have neglected and marginalized communities and people of color. While raising questions regarding the extent to which conditions have changed since the 1960s, Devin Allen offers a cultural critique that forces us to face certain sociopolitical realities. He intuitively adheres to what Frederick Douglass observed through his lectures on photography more than 150 years ago. As Douglass argued, photography can offer truth and criticism, and without criticism, there can be no social progress.[15]

11. Ibid., 7–8.
12. King, "The Other America," 4.

13. Jordan Malter, "Baltimore's Economy in Black and White," *CNN Money*, April 29, 2015, www.money.cnn.com/2015/04/29/news/economy/baltimore-economy/.
14. King, "The Other America," 7.
15. Frederick Douglass, "Pictures and Progress," speech delivered in Boston, Massachusetts, December 3, 1861, box 28, reel 18, Frederick Douglass Papers, Speech, Article, and Book File, Manuscript Division, Library of Congress, Washington, D.C.

AARON BRYANT is Curator of Photography and Visual Culture at the National Museum of African American History and Culture, Smithsonian Institution.

MY BALTIMORE

MY '70s BALTIMORE
UNITY, FAMILY, FUN, GOODNESS

I had grandparents: my "Grumpa" worked, my "Grumma" stayed home. My Grumpa was mad when my Grumma got a part-time job. He said it made it look like he could not provide for his family. I had two parents; most of my friends did. Both of my parents worked; they loved me and my brother. My mom, the oldest, had three sisters, so my dad became their big brother.

On Grantley Street in Northwest Baltimore, neighbors knew you and your parents. If I acted a fool at the end of the block, my parents knew before I returned home. When I got home, my parents addressed me, not the adult neighbor, who knew my parents were not "raising me that way" (that is, to smoke cigarettes).

Officer Friendly was always in our schools, talking about being safe, like how we should cross the streets. Officer Brown was always walking in our neighborhoods; he also lived in our neighborhood of Baltimore City, not in a whole other state.

Down in the "Village" we had block parties—the streets would be blocked off so we could dance, play, and eat. The corner stores were owned by our neighbors and they provided many of the juices and treats.

The neighborhood rec centers cost twenty-five cents to join, and there we learned how to walk, sew, set a table—learned how to be a lady! Sports for the boys, with teams sponsored by our neighbors who owned the businesses in our neighborhood. Saturdays we spent time watching the rec centers compete against one another. Game over—let the cookout commence.

Super Sundays—riding the MTA bus all over Baltimore City for fifty cents! Visiting friends over East and West. They still have not repaired the homes abandoned during the '60s riots by the people fleeing to the counties.

Rec center dances were a dollar, Poly Dances were five dollars, Dru Hill (Druid Hill to others) Park on Sundays; the music was so good, they better play Flash Light! Wait, I must mention that we had petty fights with fists, but shootings and guns—NEVER.

Baltimore clubs: O'Dell's, Giovanchey's, Pascals, the Capri Lounge, Gatsby's, just to name a few. In Baltimore City, we partied hard. *Ooh, sorry, I stepped on your shoe. No problem; but man, those are some sharp shoes, where you get them from? Mondawmin Mall at the Diplomat Shop, or was it Cookies?* No altercations. Because it was late, party time was over. It's just time to eat; meet me at the Steak and Egg on Reisterstown Road or York Road.

No fear of being shot or carjacked, which was not even a thing. But if the next day is Sunday, you better be up for church, or you will have to answer to your Momma.

Now junkies, oh yes, they were there for sure, because I remember Vietnam. Some of my male family members

served. So of course, there were drug dealers too. But these dealers had class and, most of all, intelligence. They made that money and opened some legitimate businesses and *got out of the game*! Because most of these men were smart enough to know that dealing was not a lifelong thing. They were not doing it for the *bling*. No, it was to get a little leg up for bigger and better things that were mostly for our neighborhoods: beauty salons, barber shops, dry cleaners, and sub shops. Yeah, we once owned them all in our neighborhoods.

MY '80s BALTIMORE
CRACK, OH MY BADNESS. NOT GOODNESS

What in the hell is going on with my girlfriends? My "have to go to the beauty salon, shopping at Linda Lynn's every other week" girlfriends? See, we had jobs that paid biweekly. They are now looking crazy, their hair not done. Why are they talking and walking so damn fast? Do I want to buy what? Why are you and this man out here selling socks, cigarette lighters, and soaps on the damn street corner?

Someone was shot over in East Baltimore, two shot in the Park Heights neighborhood and Edmondson Village and now on Garrison Boulevard. That's my neighborhood! What the hell has happened; what the hell is going on?

Well, for me it was Reagan, that actor—you know, made a movie with a chimp, a monkey, or whatever; now he's the damn president! He cut Social Security Insurance (SSI) benefits for kids over eighteen. See, before Reagan cut that off, I could have collected benefits until I was twenty-three years old, as long as I was in college. So now I can't finish my studies at Towson State because my dad died when I was entering high school. My mom worked, but she also received SSI benefits for her two kids by her husband who paid into Social Security for years; you get what I'm saying?

Working for the FBI in DC, I was hanging with friends one night sipping and smoking—yeah, we smoked naturally grown weed (no additives for us, DC could have that "Love Boat"). We were reading and talking about this "AIDS" thing. Damn, now we have CRACK and AIDS!

Our marriages (some may have been shotgun marriages) are now failing because Dad can make some fast money selling crack. The government is willing to help Mom as long as Dad is not there. Hey, government, what about helping the whole damn family?

The jobs in the steel mills and factories, as well as in other manufacturing companies, are going if not already gone away. The rich can save some money moving manufacturing overseas. No more free labor in the USA (slaves, Jim Crow Blacks) but there is cheap, really cheap, labor in places overseas.

Oh, Lord! Now Mom is on crack. Let me say this—in Baltimore, powdered cocaine did not really affect the Black Americans like some thought it would. In Baltimore we had not overcome but had made some great strides—still, that much cocaine was too damn expensive for most. Along came crack—cheap and addictive as hell, hyperactive-addictive, taking-everybody-out-their-damn-minds addictive . . . but the money!

See, these new dealers want to show off; somebody forget to tell them this is not the noblest of professions. Dealing is not meant for the long haul. Dealers don't flash their money. They make that money work for them. But look at you, you still working for the money! There was nobody there to tell them this. OGMs (Original Grown Men) are gone, in jail, strung out, vaporized in our neighborhoods, gone to the counties, thinking it's not their problem anymore. Wrong!

Now grandparents are raising the grandkids when they should be done raising kids. They are not ready for these kinds of grandkids. These kids have seen some stuff. Grandparents should be relaxing.

What the hell is going on, Baltimore? Two shot where? Three killed over in East Baltimore. Where the hell are Officer Friendly and Officer Brown? All I see now is Agent "Mad Dog"; he's running through the neighborhood like a wild savage. He's supposed to be the damn police? Where is he from? He doesn't know where Poplar Grove is!

I'm a mom now to a young Black boy. He's my world, and I want to make this his world. Because I don't stand for no foolishness in my world, now that I'm a single mother by force not by choice. My son was born into a marriage, but it's okay, I'm smart, book smart and street smart, and I have an awesome family that has values, accountability, and most of all love!

Now crime is out of control. What happened at the corner store? They shot Mr. Bonner, our neighbor. He's gone (RIP) and so is his family. There are too many memories, good and bad, but now they are really bad.

The Johnsons would like to buy that store now, but no, there are no loans for the Johnsons, Browns, Williams, or the Allens. But wait, this new owner doesn't even speak . . . never mind. Now I see this sign in the new store that reads "*No Credit Not Even a Penny.*" Damn, so you are willing to lose a $5.00 sale because all I have is $4.99? If I could go back, I would say, *Go somewhere else to buy, don't go get that penny and come back to this mother-fucker*. DAMN. Excuse my language.

This makes me want to holler!

MY '90s BALTIMORE

I have a son, but he's not going to be in these streets. His dad is not here, not monetarily or physically present. But that has nothing to do with me. I am a strong, proud woman and mother with strong men in my family. Because I am smart and I know who I am and where I came from—regardless of what they did not teach me and still don't teach in school—we will be great.

My son, my daughter (I'm married to her dad), and now my granddaughter will see how I, my mom, my brother, aunts, uncles, and cousins move. They will learn some things that mothers should never have to teach a child about how to move in this city, move in this world. Unfortunately, they must move this way only because they are Black children. They are going to understand the good, the bad, and, most of all, the beauty, love, and peace that we have—that our people have and deserve.

GAIL ALLEN-KEARNEY, Devin Allen's mom, lifetime Baltimorean, mother, and grandmother.

"GHETTO."

When most people think about the word "ghetto," they think of poverty, struggle, pain, violence, drugs. But for me, the word "ghetto" is so much more. When I look deep into my community, I see a beauty that is often overlooked and unappreciated.

"UPRISING."

There are so many different aspects to an uprising: rioting, looting, cookouts, block parties, prayer circles, town hall meetings. The Baltimore Uprising gave people like me a voice. Since the murder of Freddie Gray, my city has not been reborn, but it's on its way. Some people talk about how we destroyed our own community, how we burned down a CVS, how we looted a mall. A mall? Its inventory can be replenished. A CVS can be rebuilt. Freddie Gray cannot be brought back.

When you're documenting moments like the uprising, you don't have the time to think about yourself or your well-being. I get a certain type of adrenaline rush when I'm in the mix of everything. I shot the majority of my images on a 35 mm prime lens and my zoom was my feet. I was tear-gassed, pepper-sprayed, and hit with shields while capturing these images. My focus was just on capturing each moment and making sure every image was timeless, real, and authentic.

Young people created and fueled the uprising. They made sure the world heard their voice and felt their pain. Some referred to them as thugs, but I just see my brothers and sisters who took up arms and became soldiers.

This book is a visual story of the uprising. It's also the story of Baltimore, Freddie Gray, and so many countless others who grow up, work, and raise their families in places like Baltimore. This book is to challenge the stigma, to show the beautiful side of the ghetto, and hopefully to inspire others to love, respect, and invest in our communities. This book is for you.

DEVIN ALLEN

POVERTY IS VIOLENCE

Pretty soon empty spoons cut gums
like razor blades across faces in penitentiaries
the summer of '98 took lives
off of family porches
&
out of family portraits
it also took the Jordans off of Jermaine's feet
along with his breath
last words were
"Please don't scuff 'em!"
&
when people don't eat
They eat each other bone and all
I AM, staring at an empty closet
waiting for the bones to fall
&
because an empty stomach
gets filled with lucifer
we been keeping the door locked
every day this June
the wavy apparitions rising from concrete
reminded us, summer was in
&
the heat was on

Tariq Touré

A BEAUTIFUL GHETTO

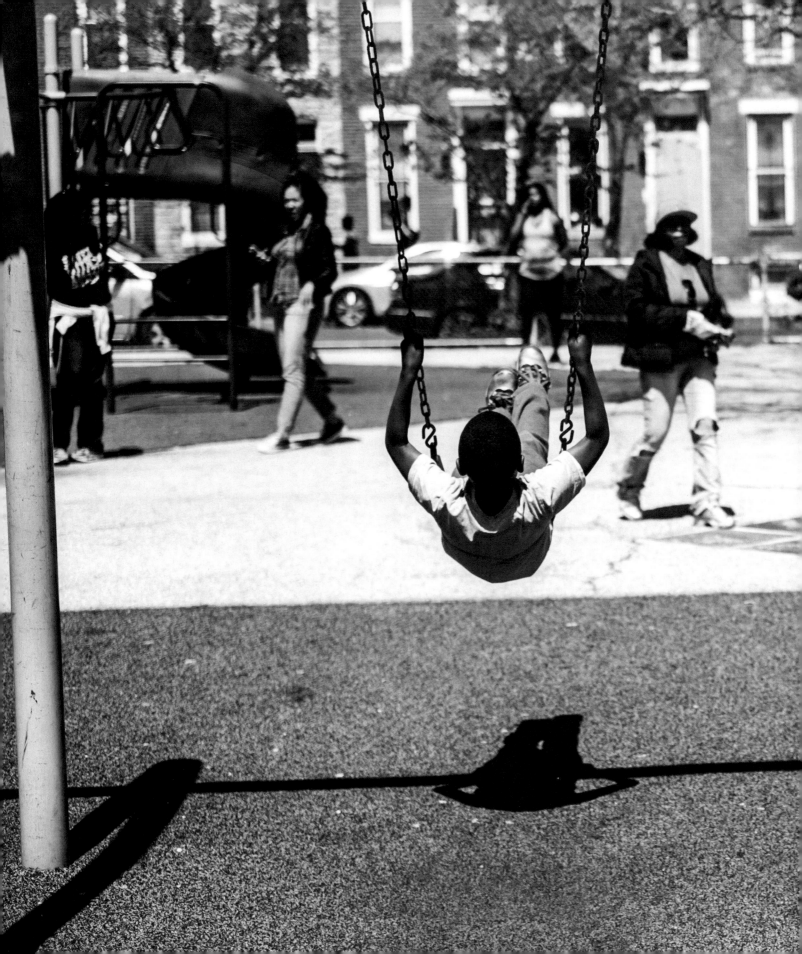

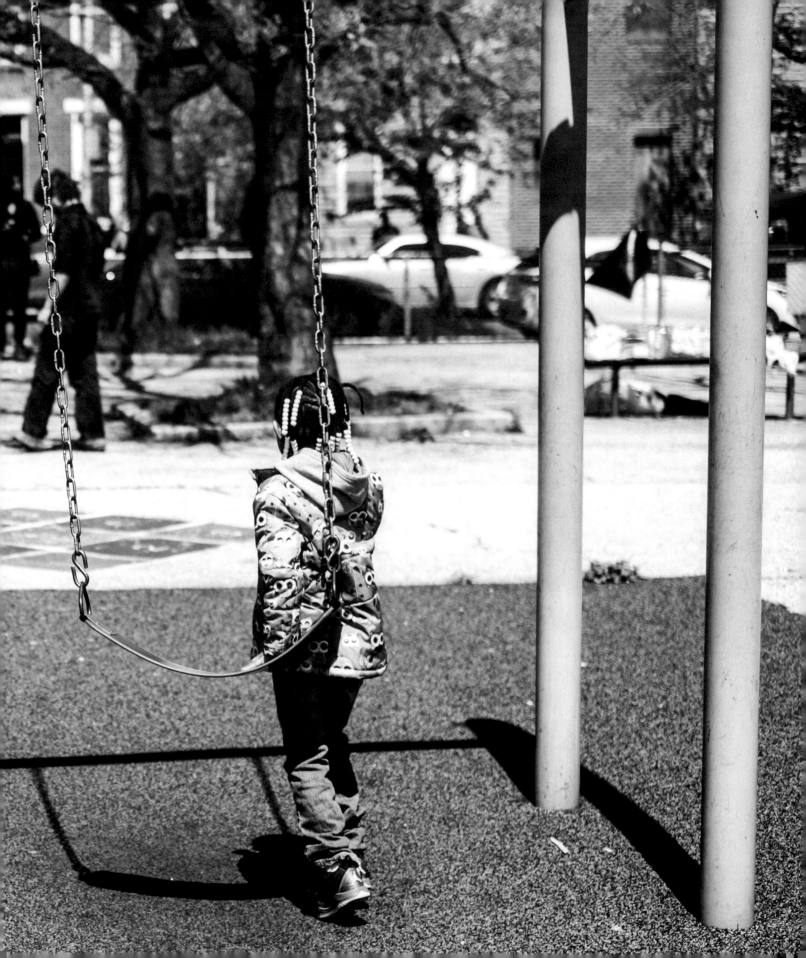

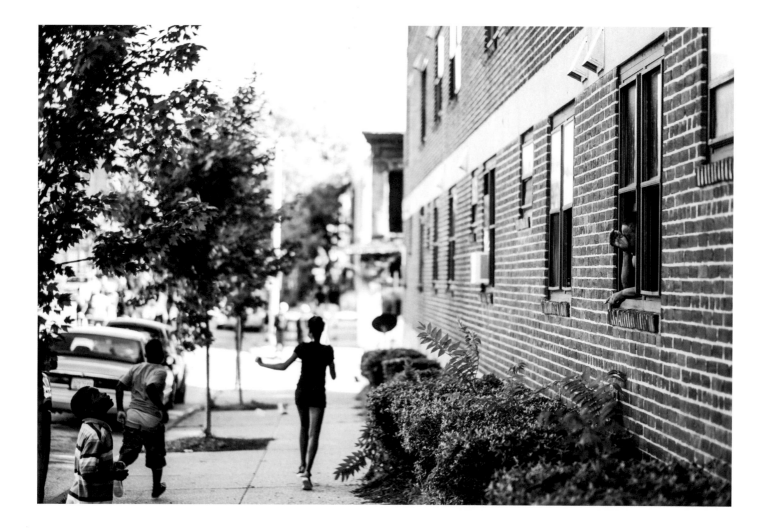

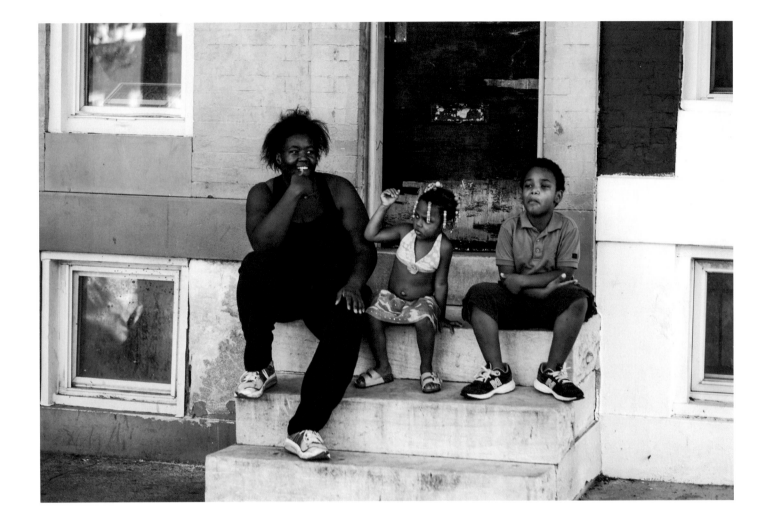

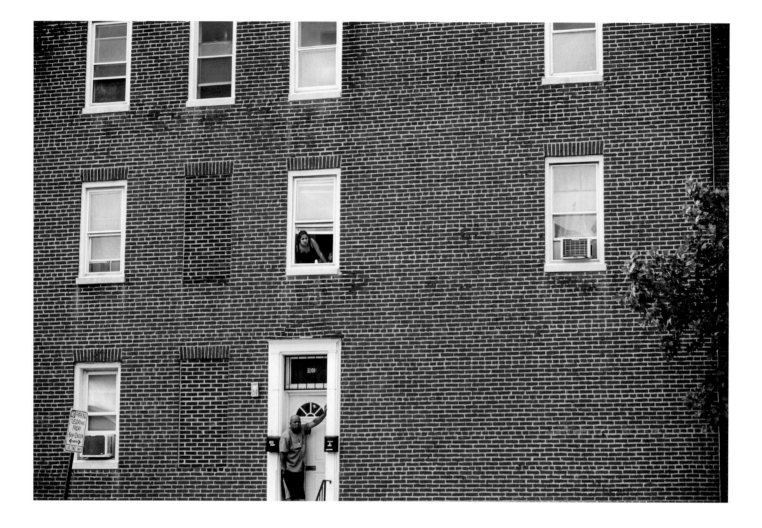

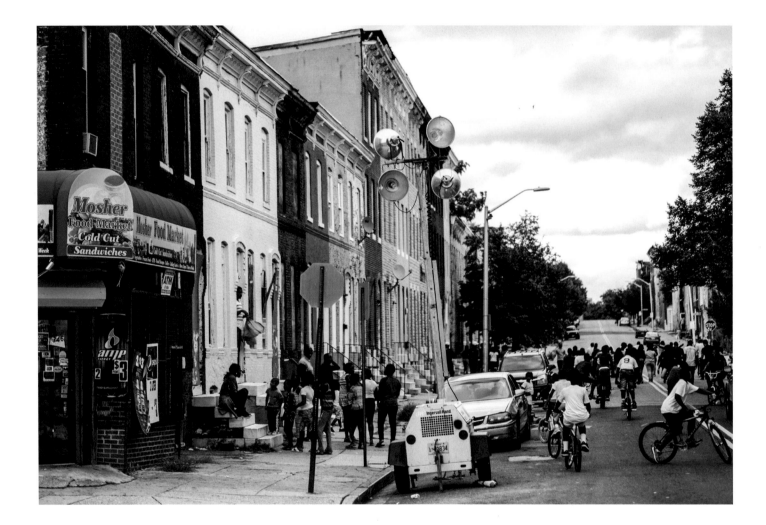

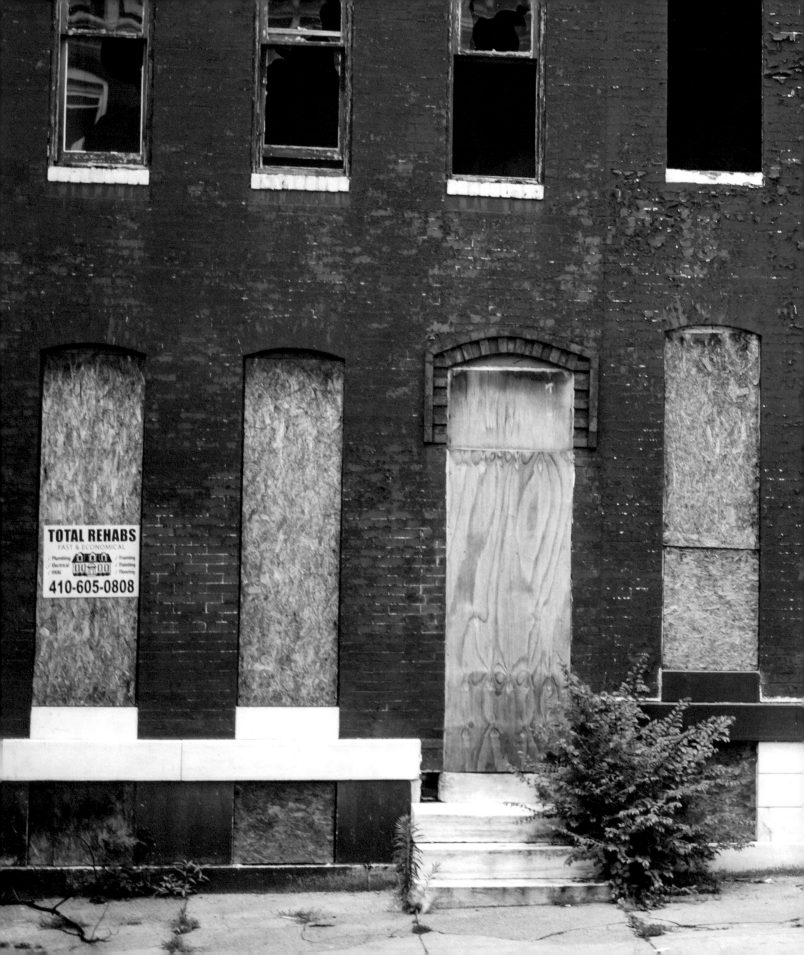

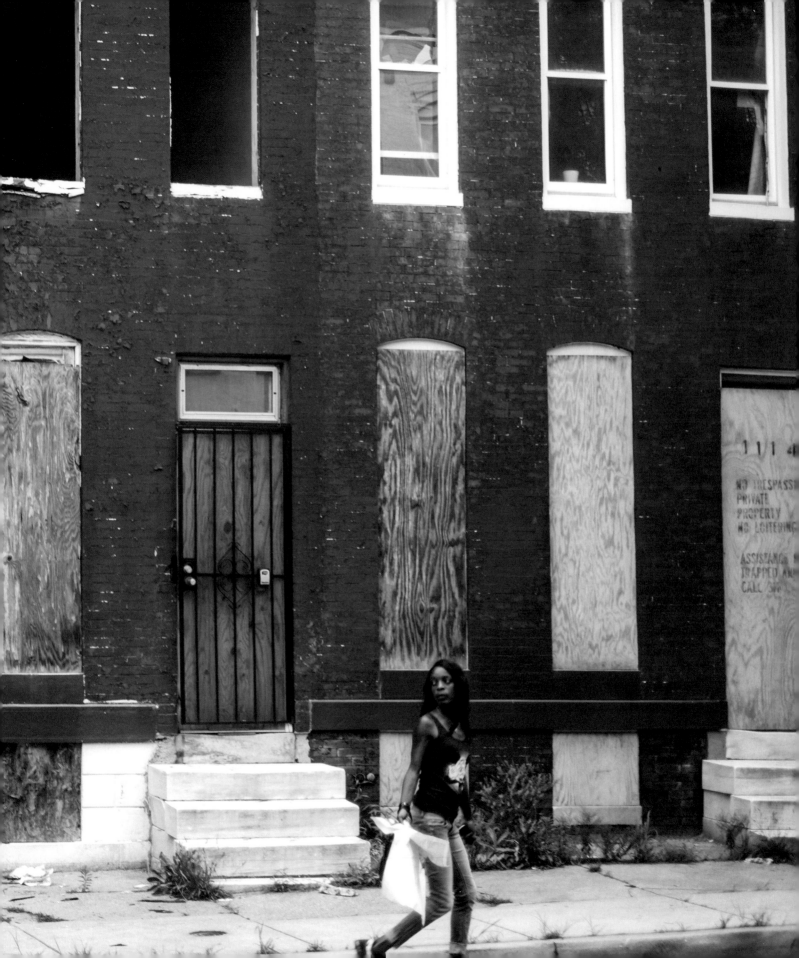

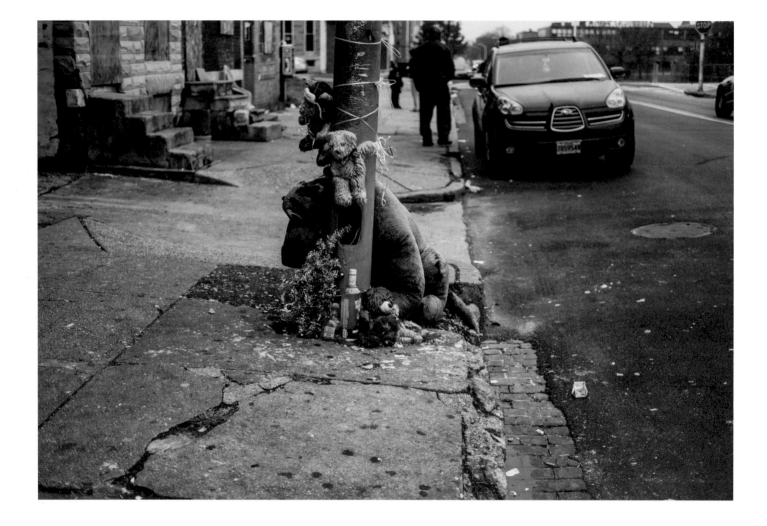

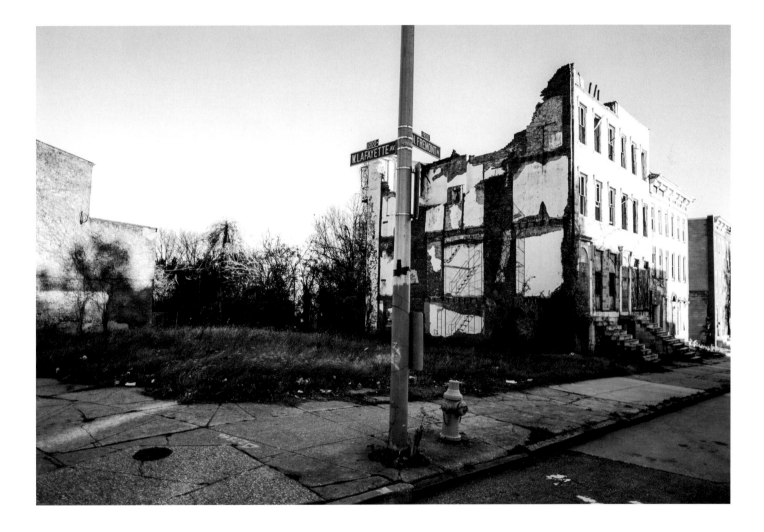

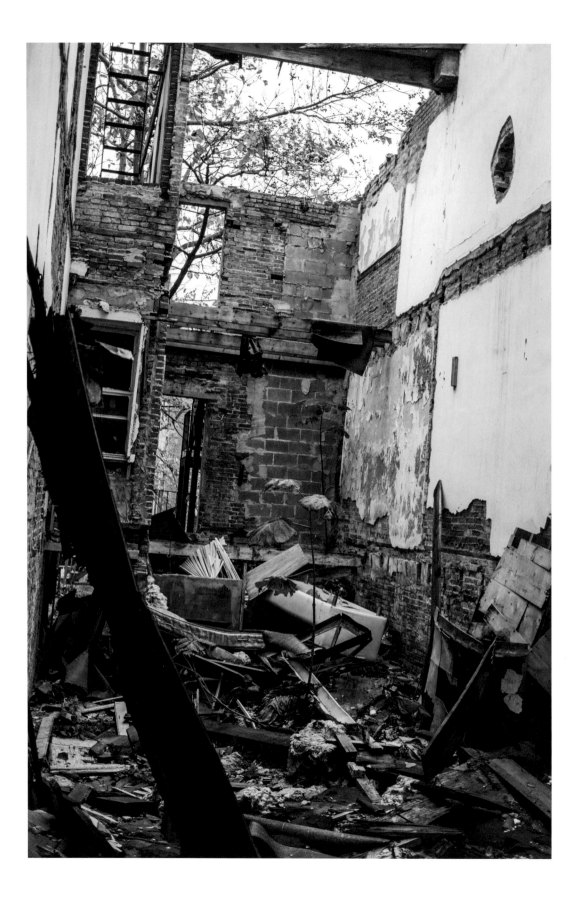

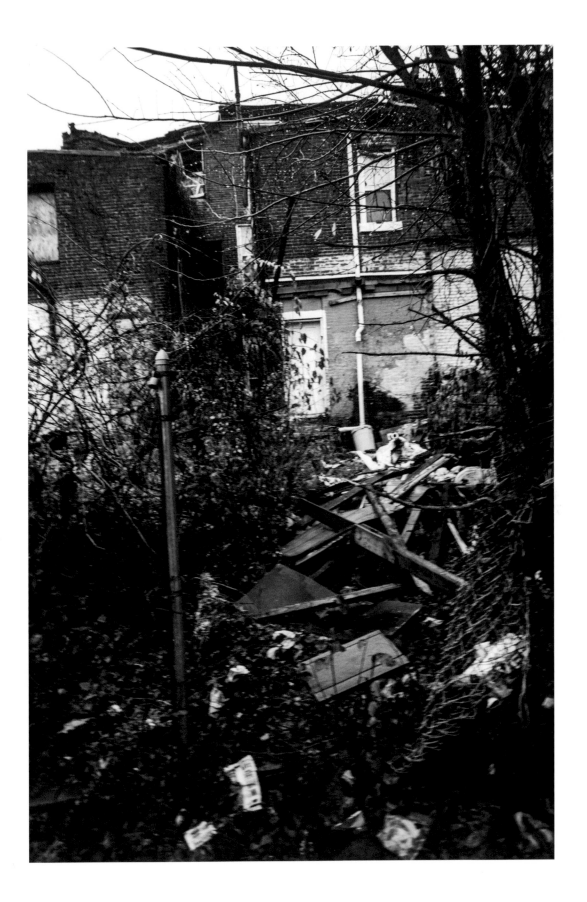

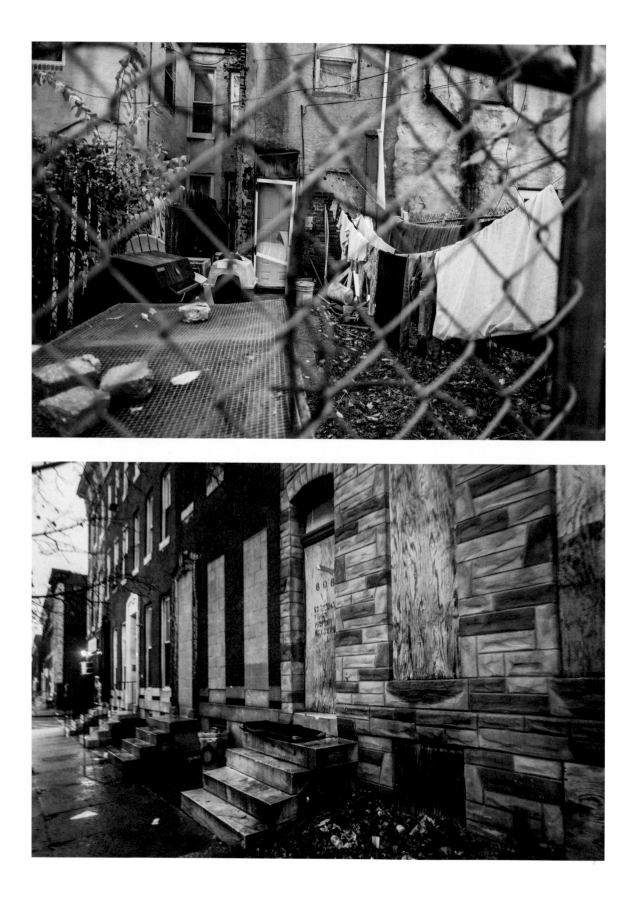

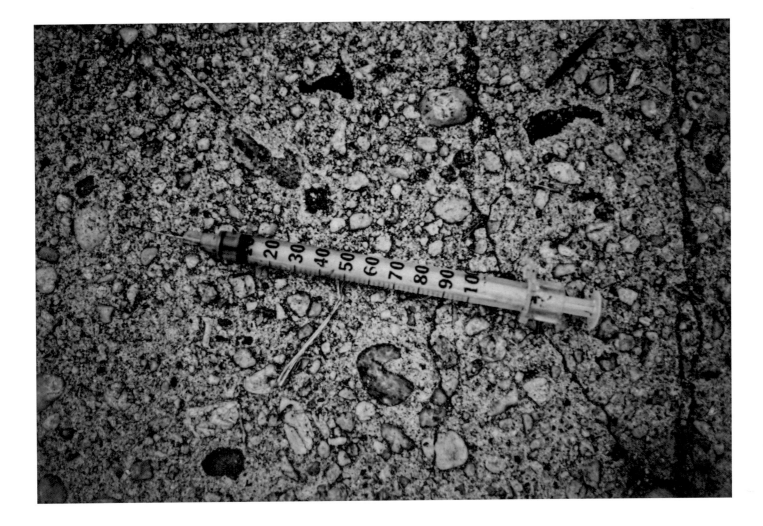

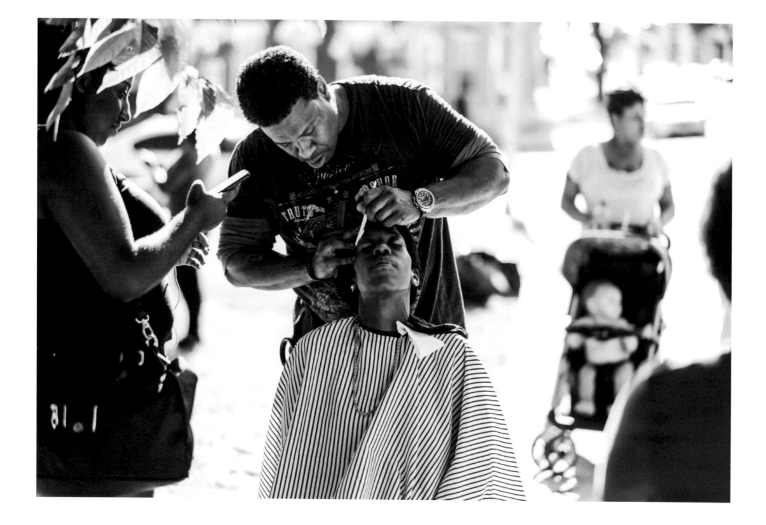

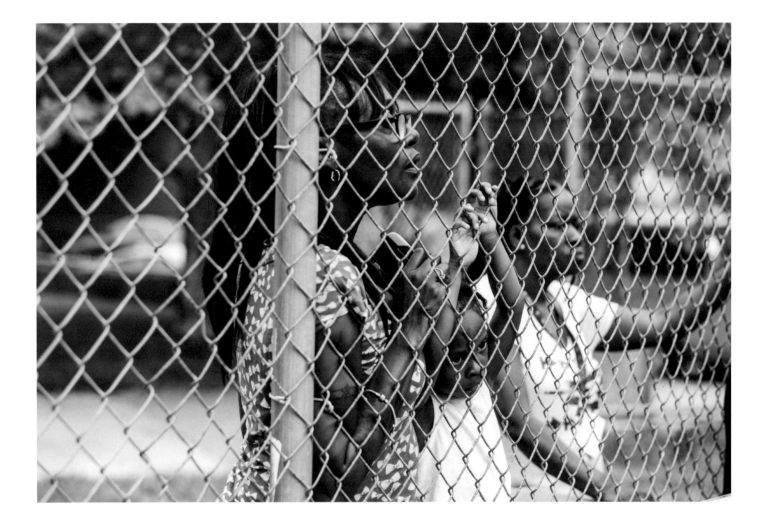

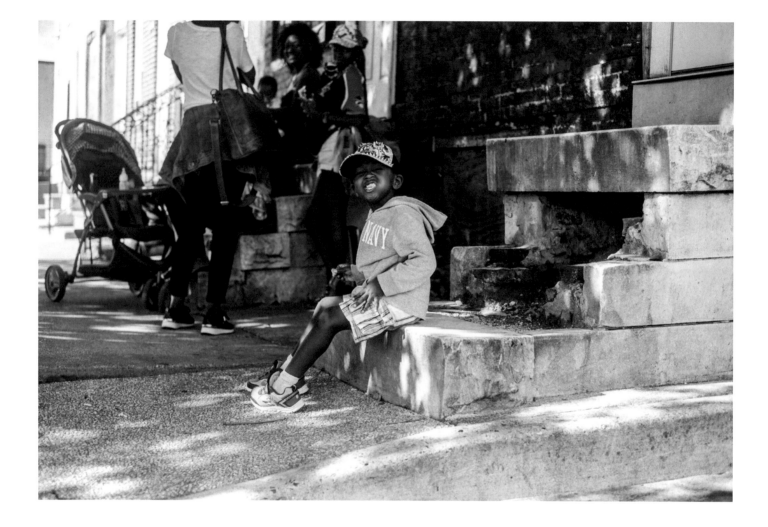

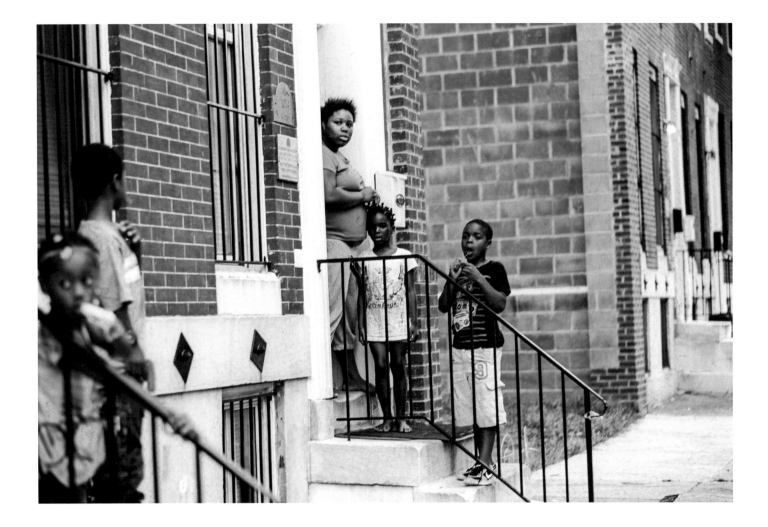

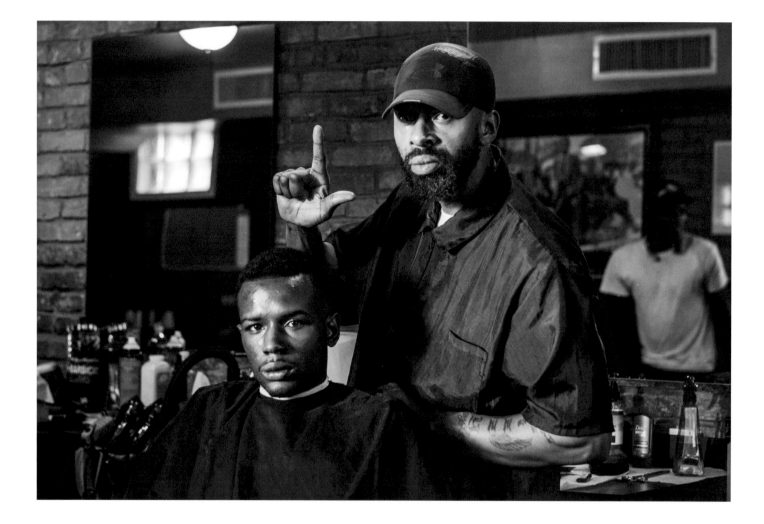

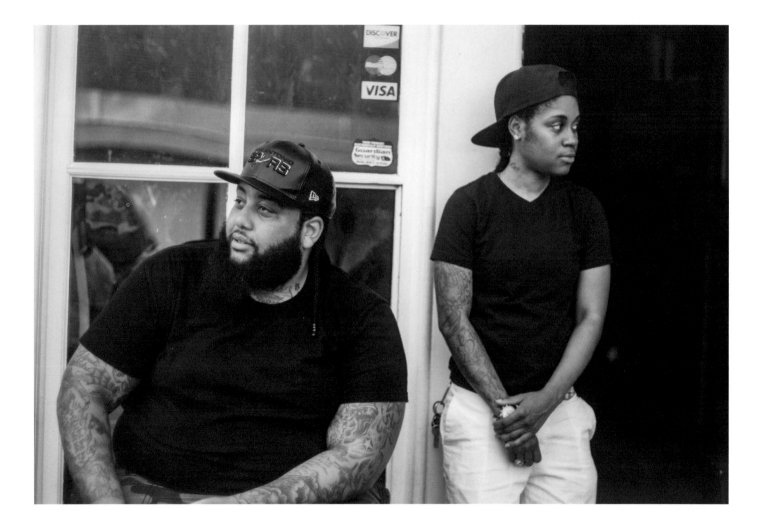

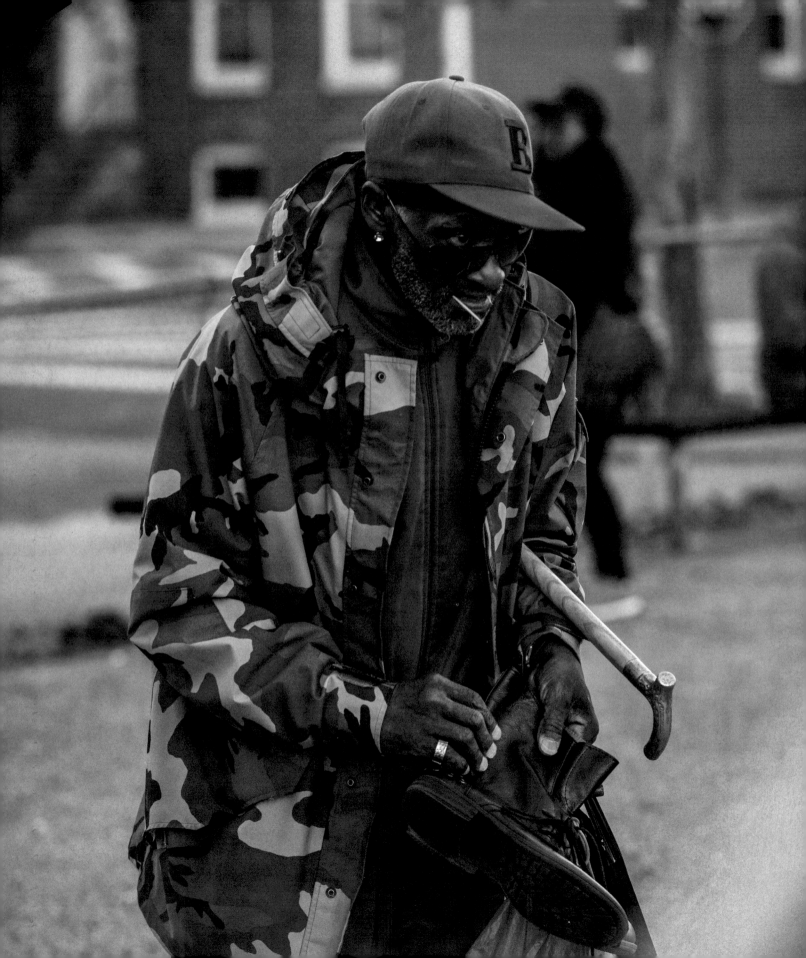

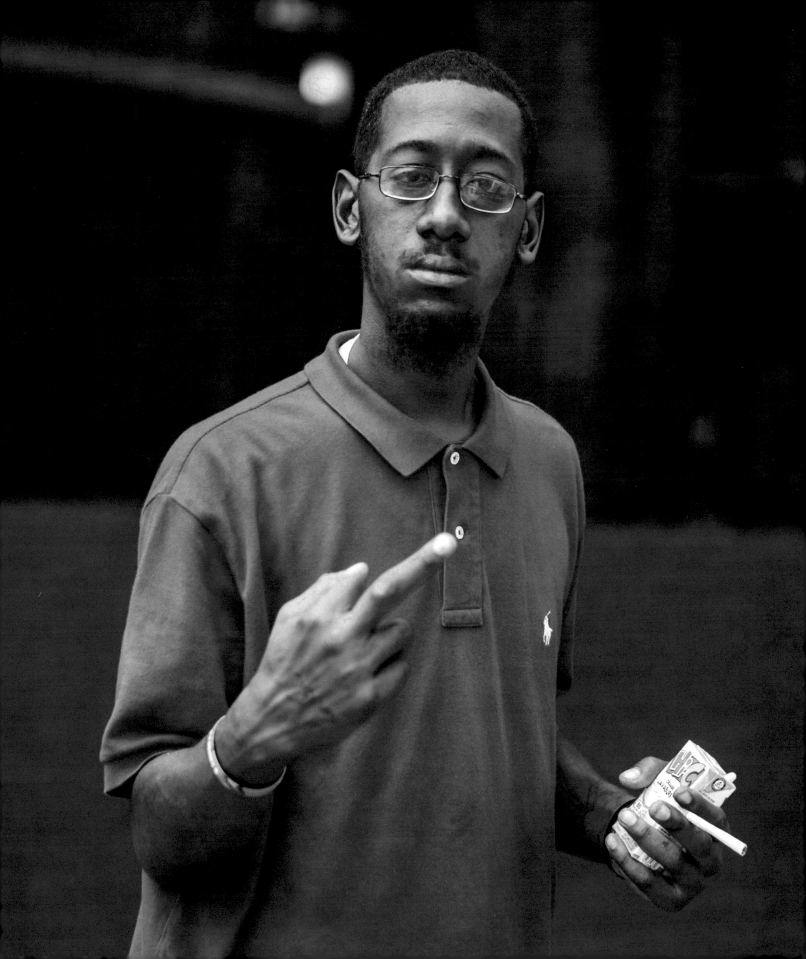

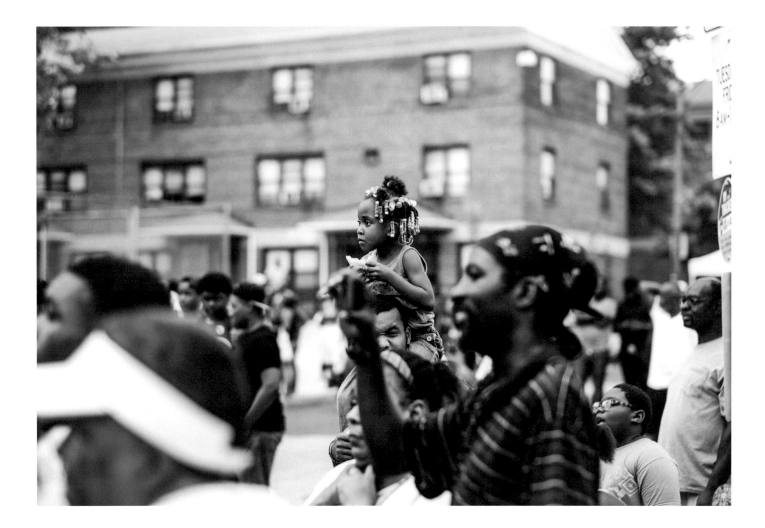

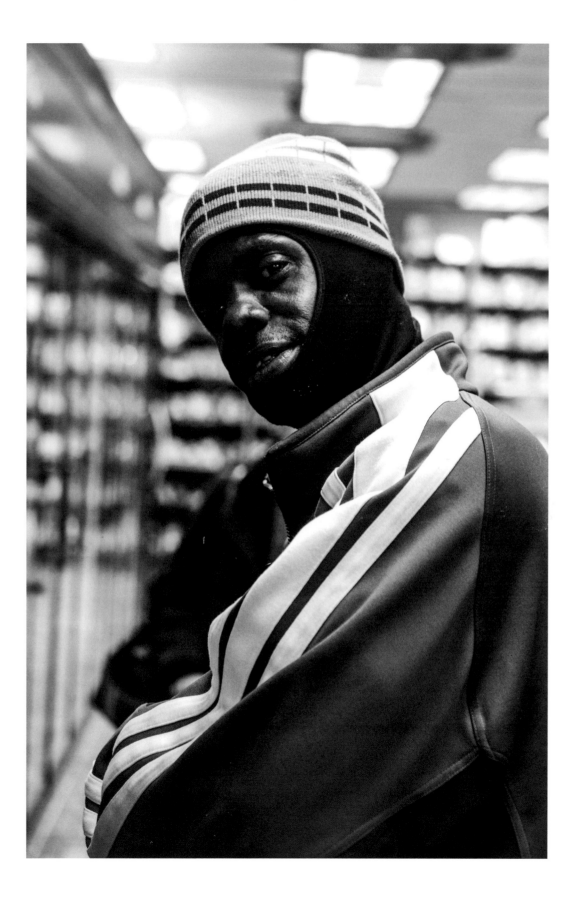

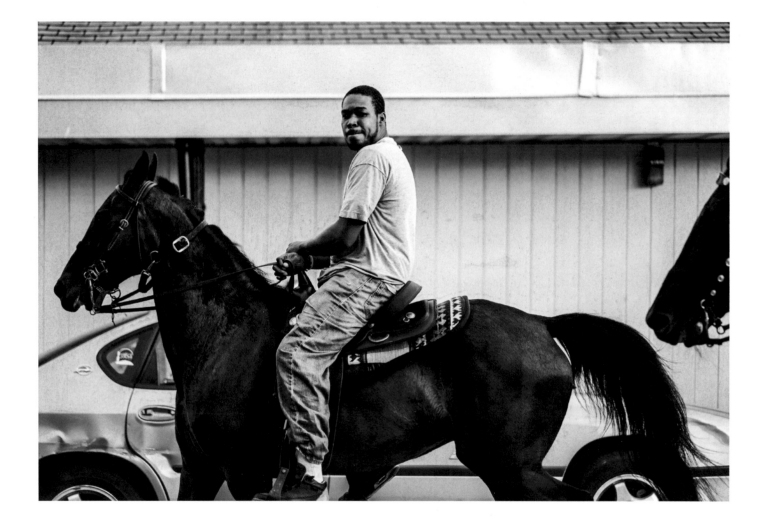

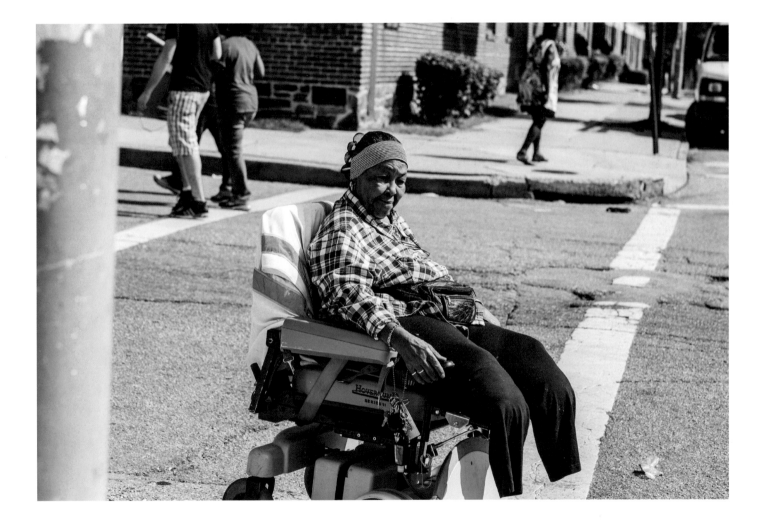

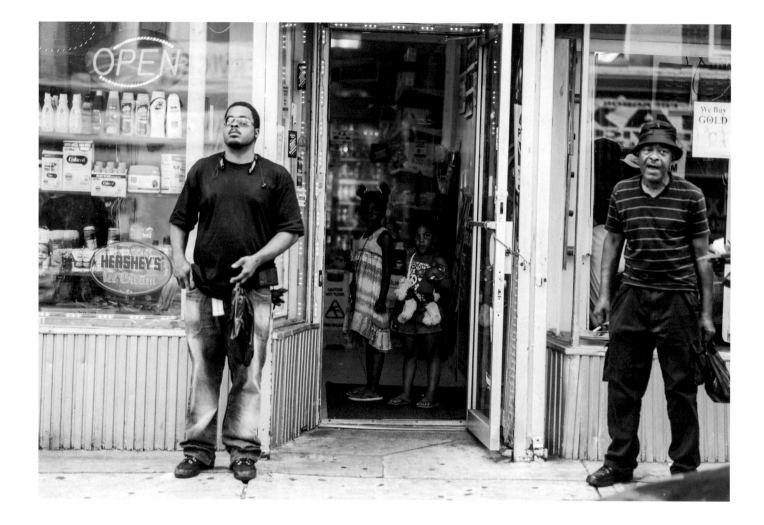

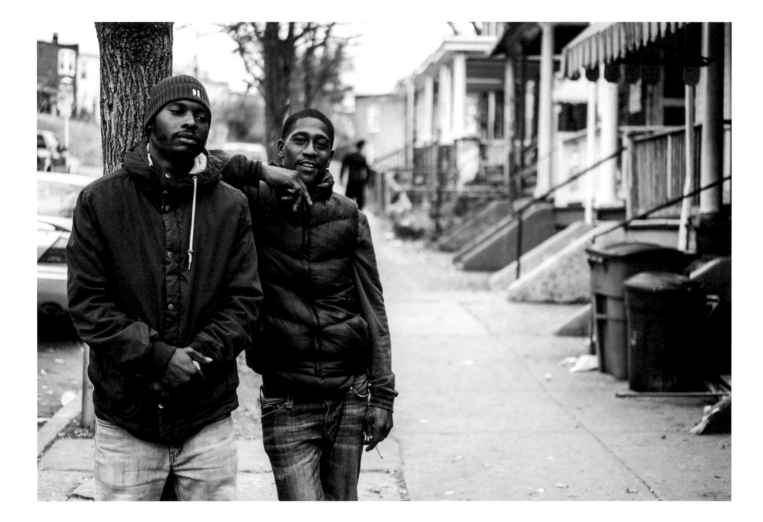

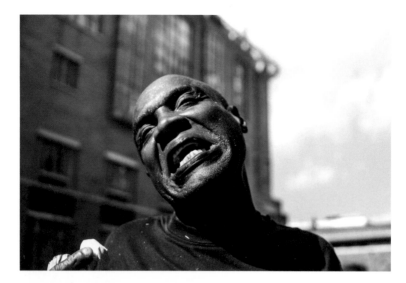

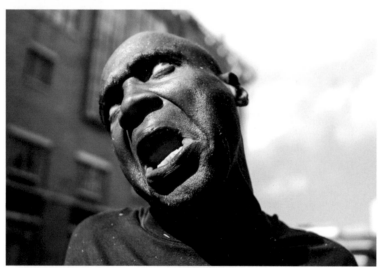

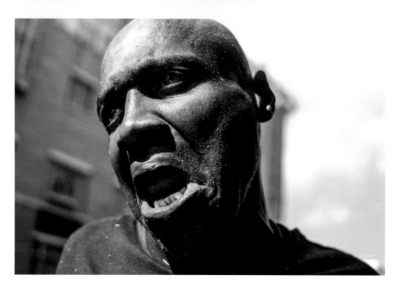

30

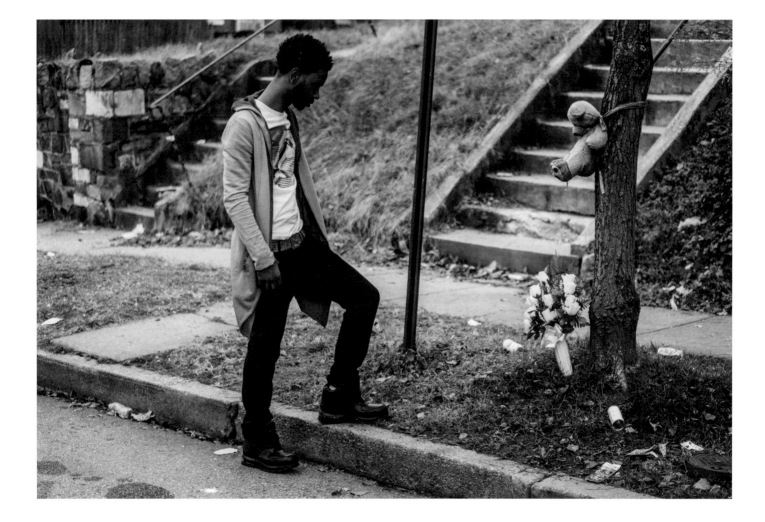

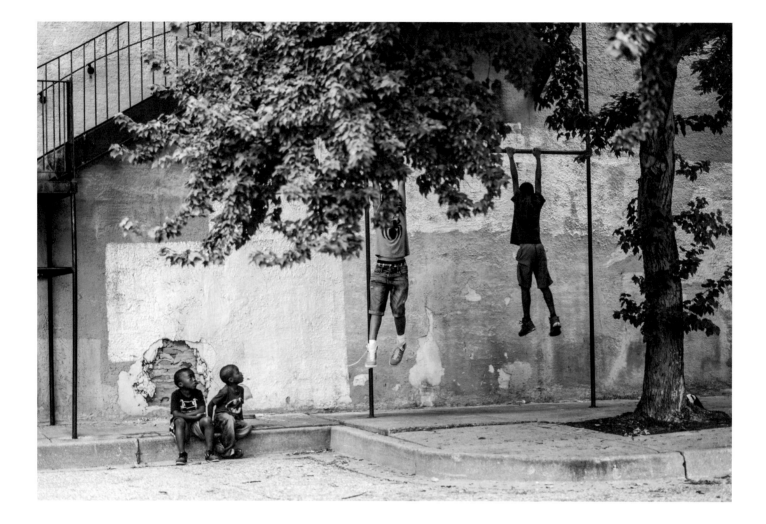

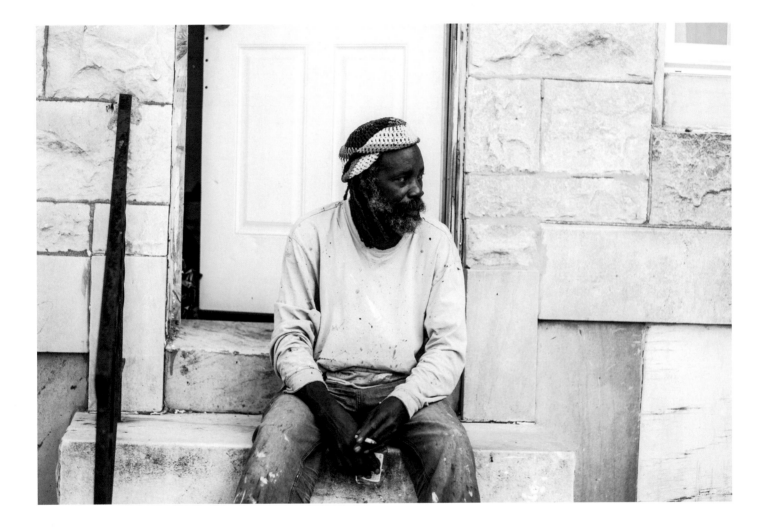

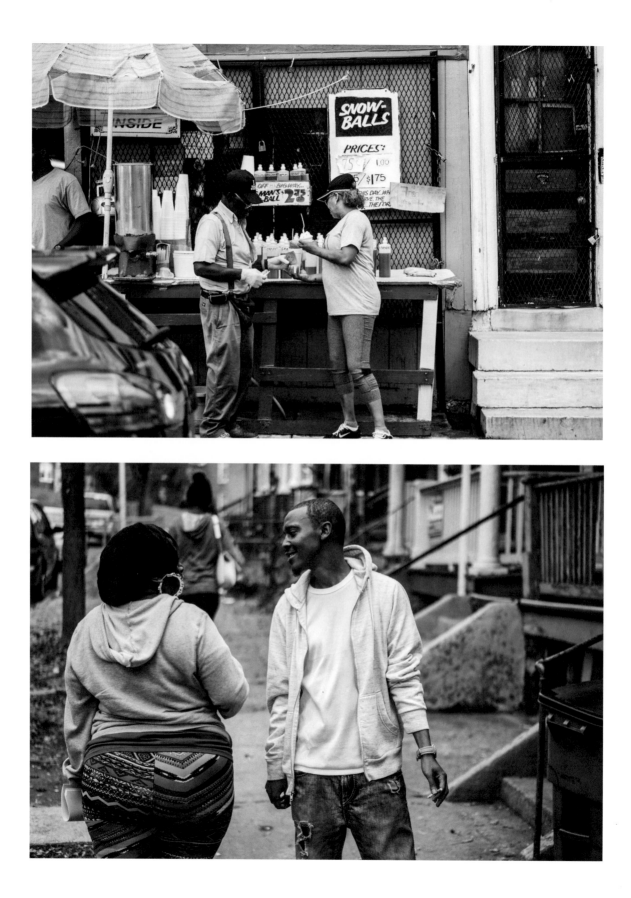

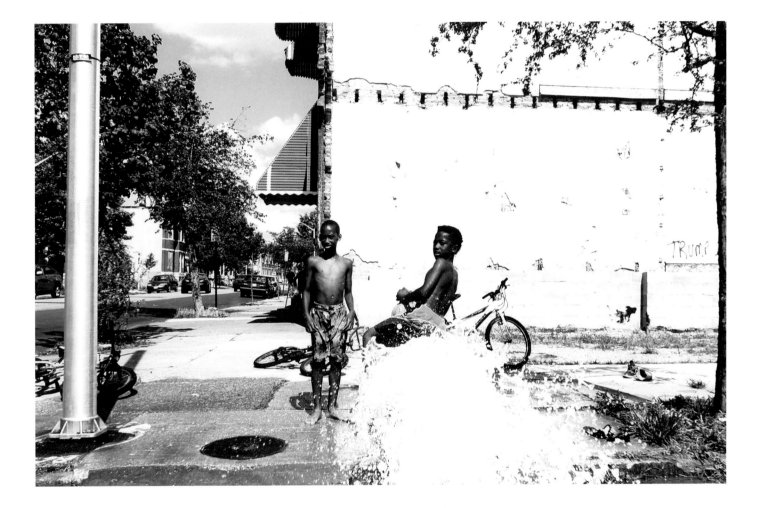

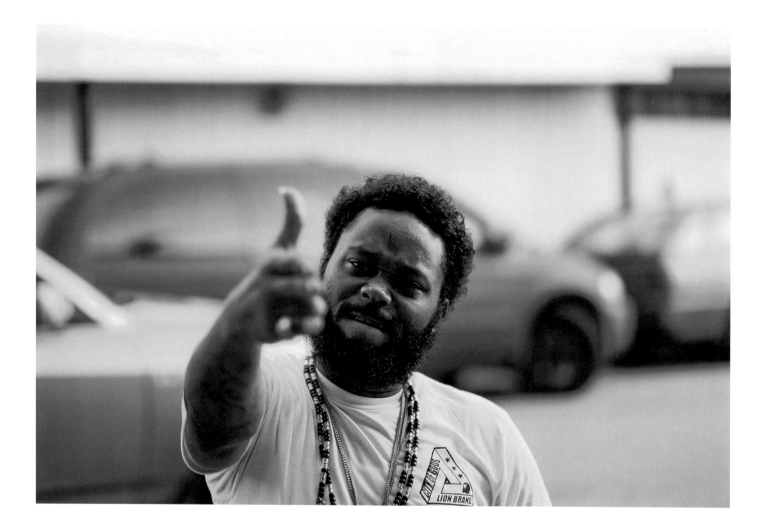

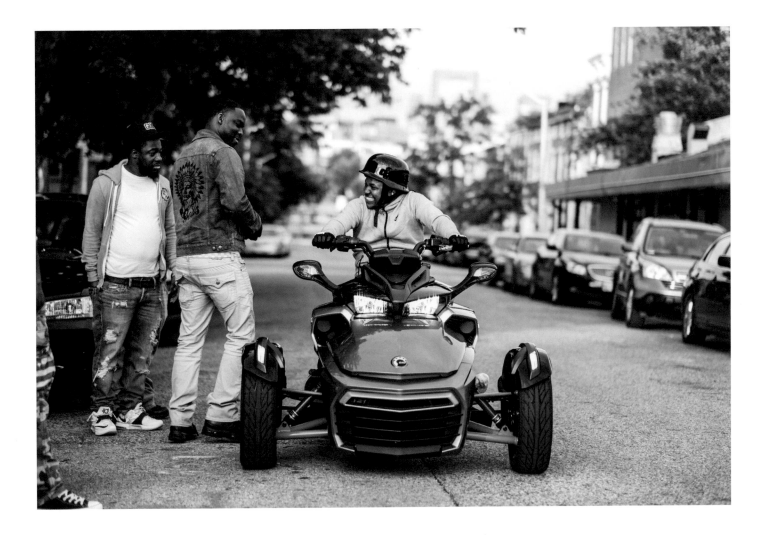

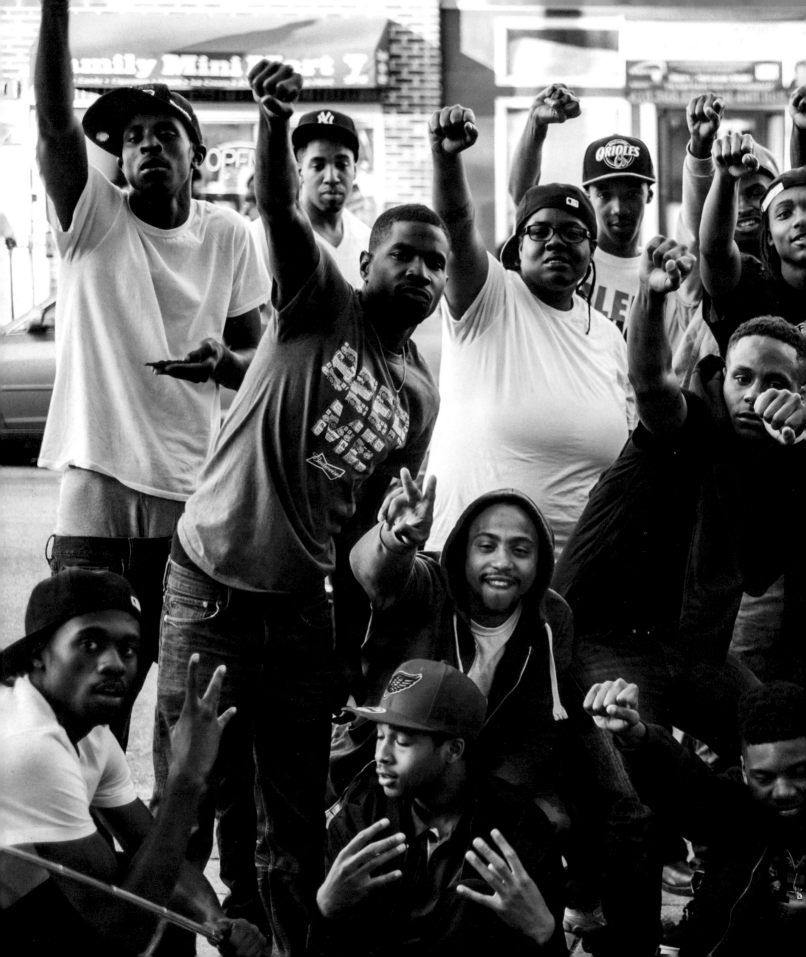

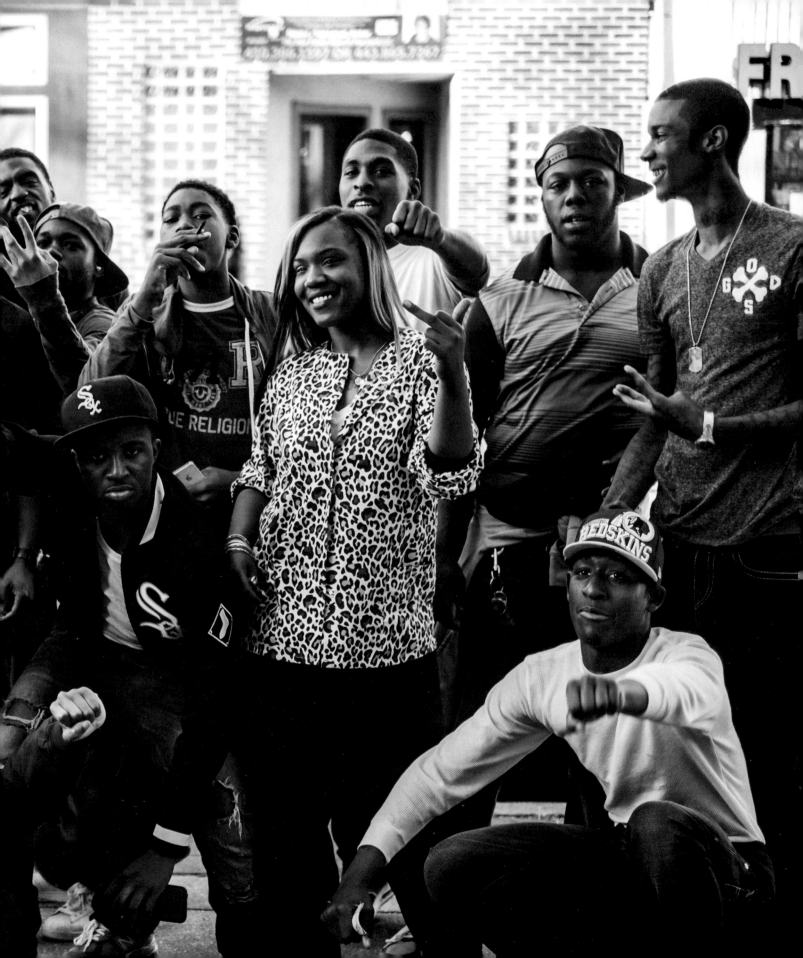

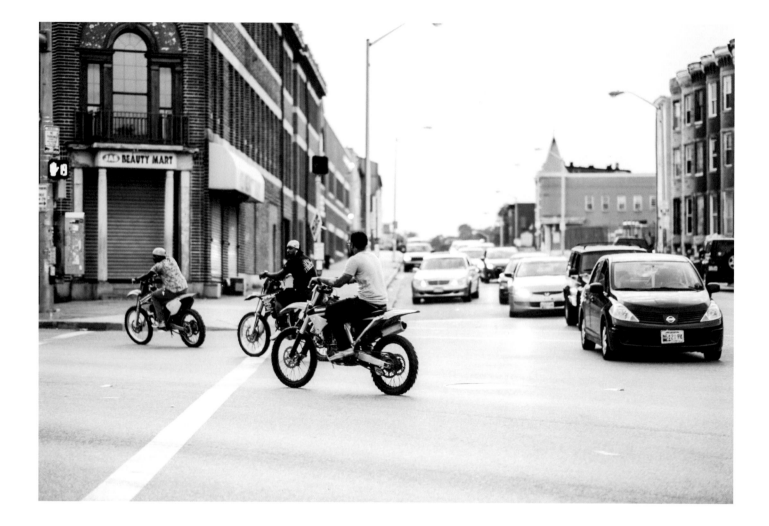

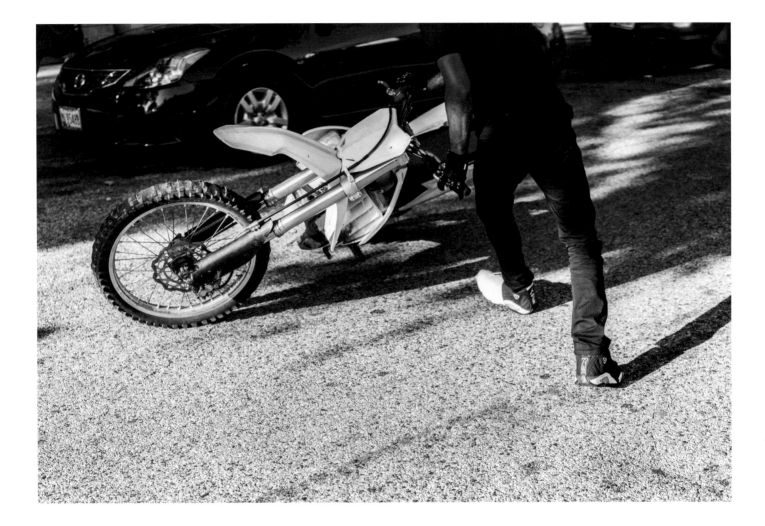

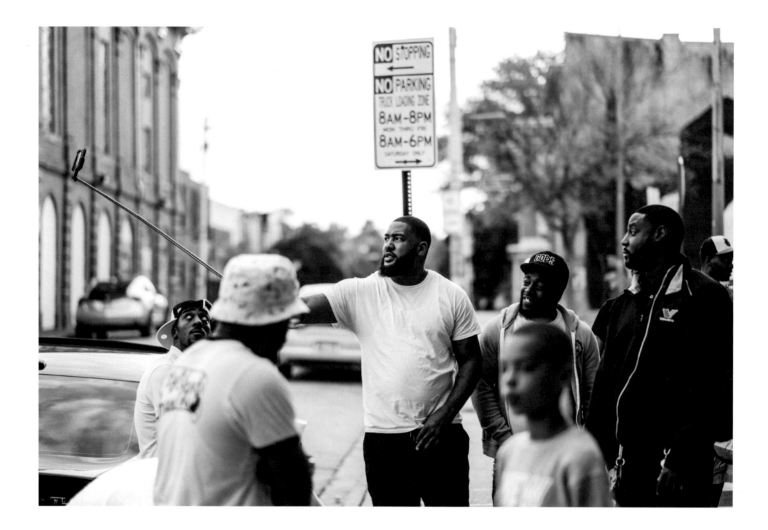

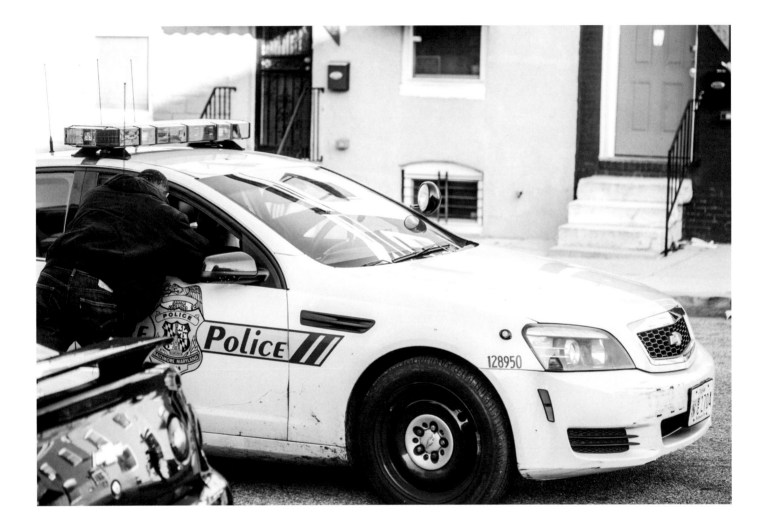

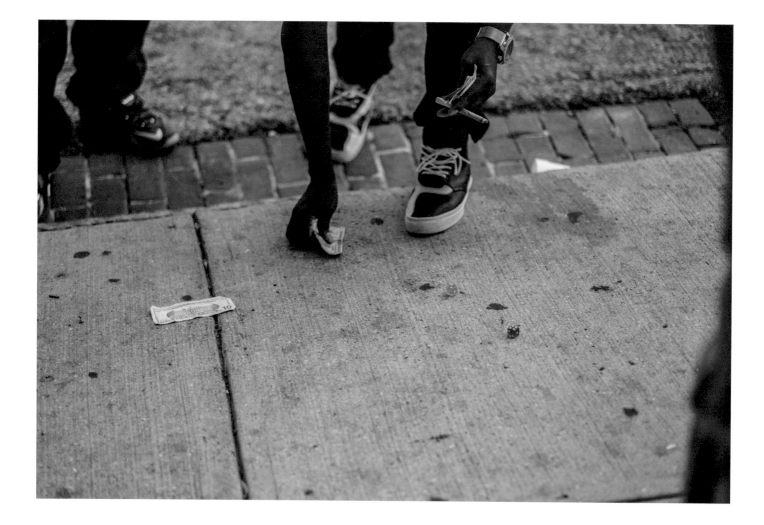

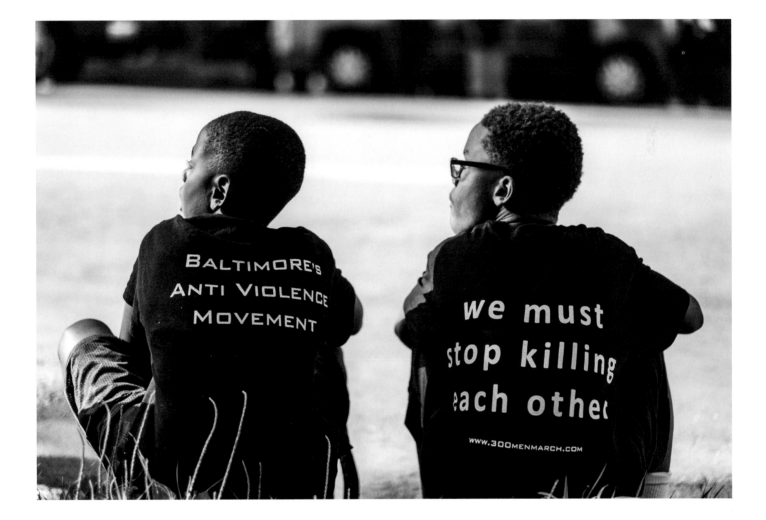

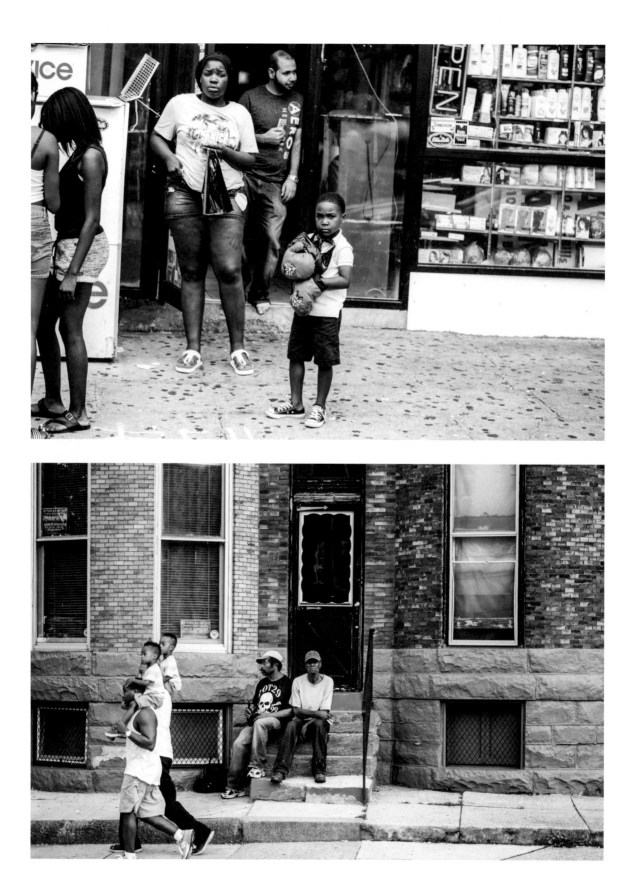

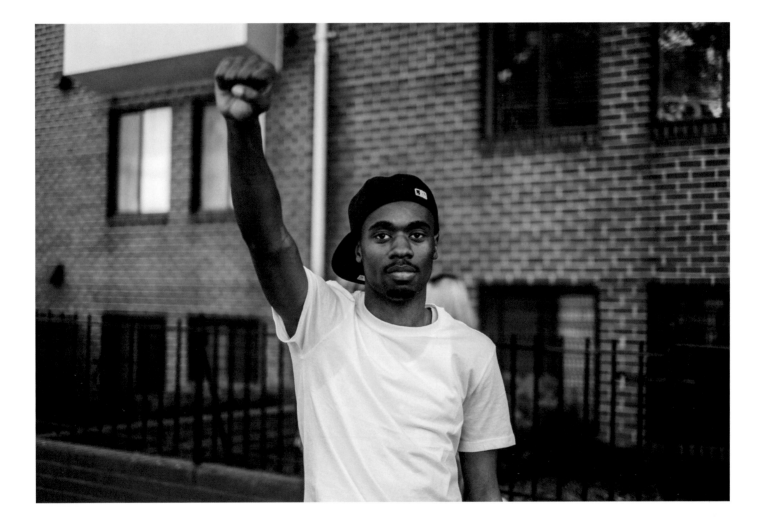

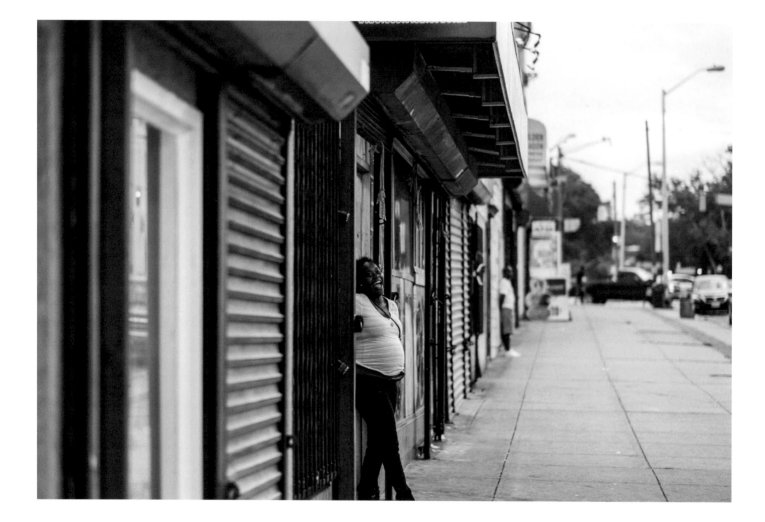

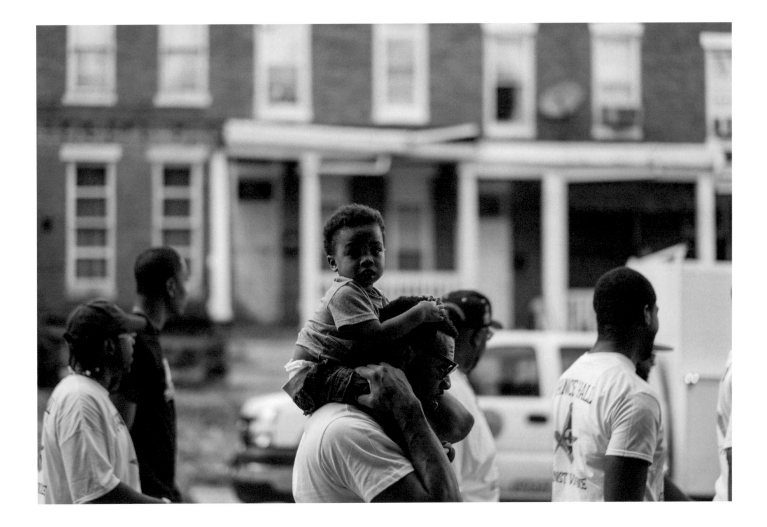

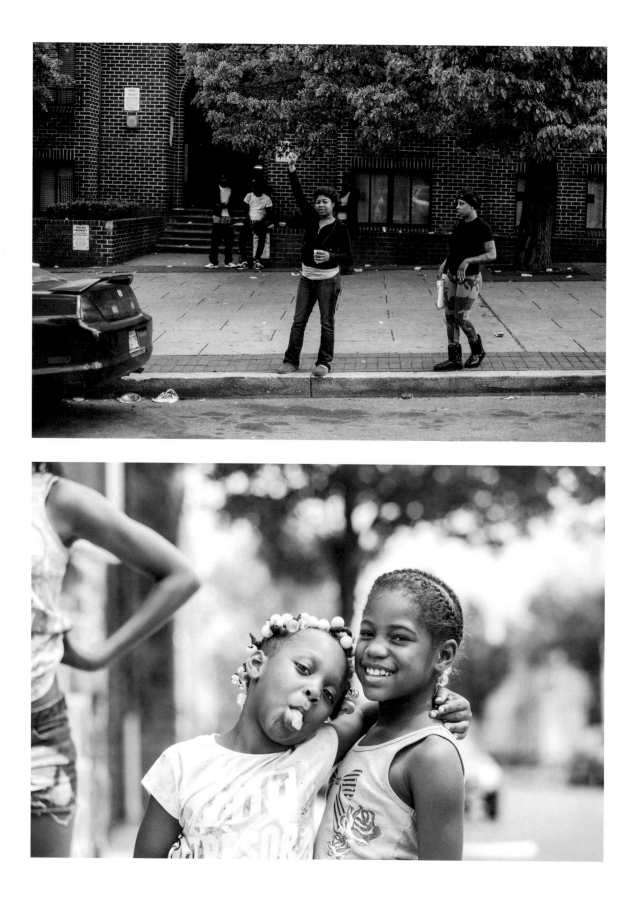

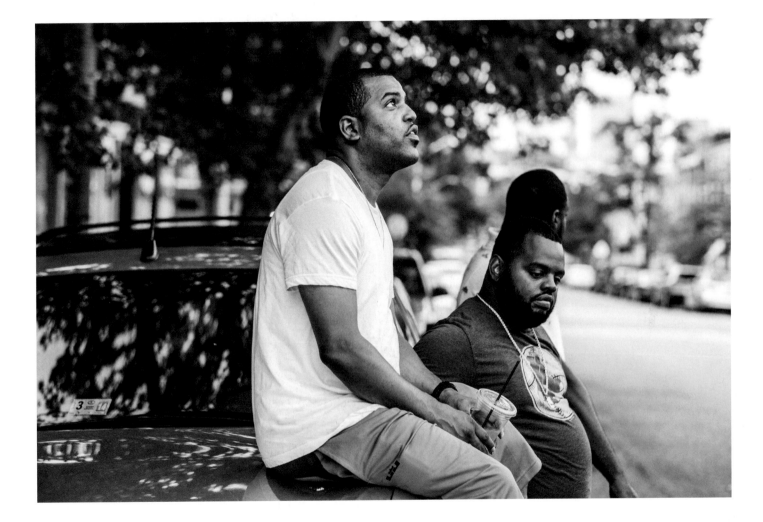

THIS BURNING HOUSE

In 100 lifetimes
these chapters will
read too well
how we rang alarms
stomped tired feet
in harmony, and how
you came with
rivers of respectability
but not a molecule of water
to put out the fire
Junior warned us of

the streets ran red
with our blood
then black
with our fist,
then pink
with our tongues,

you saw how fast
these broken windows
became broken windows
for token negroes,
taking these blows

so easily
you've chose
this moment
this sonic quaking
of atonement
as brutal labor
for eardrums

that coughing.
hacking.
heaving.
y'all been hearing
are your children's children
choking on the smoke

Tariq Touré

UPRISING

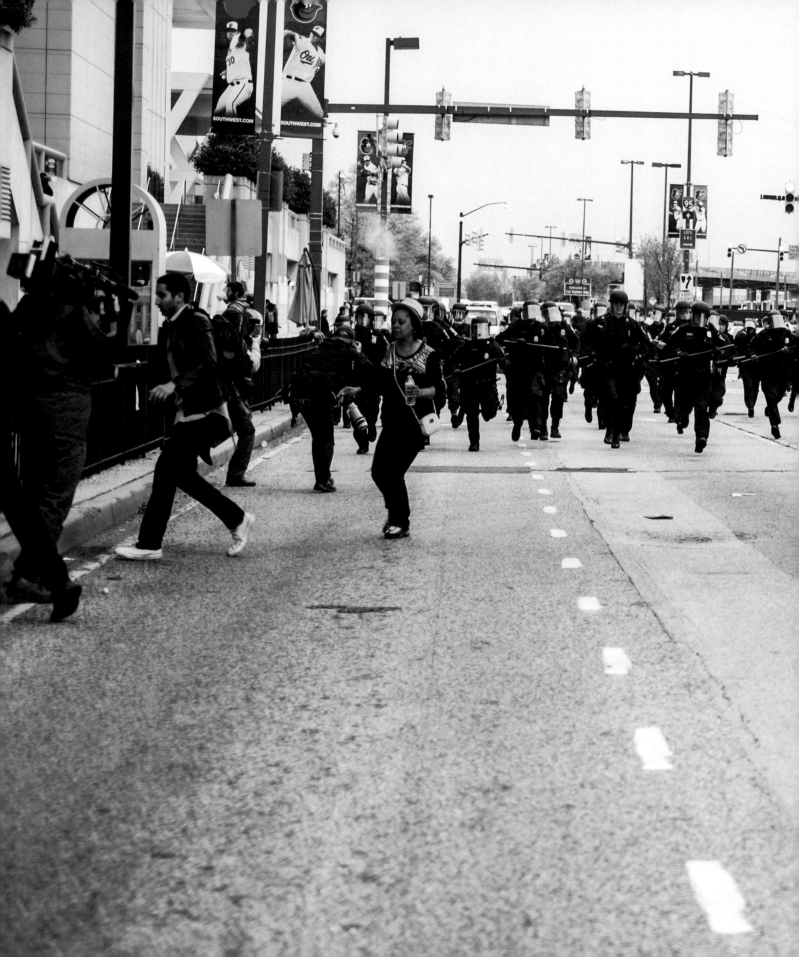

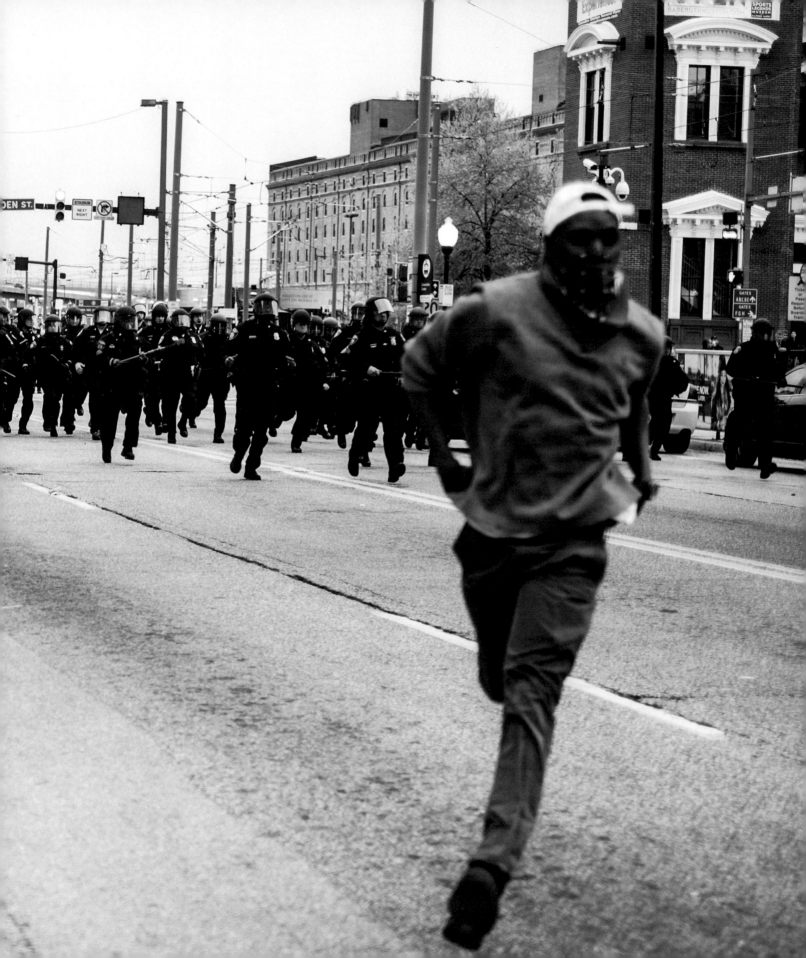

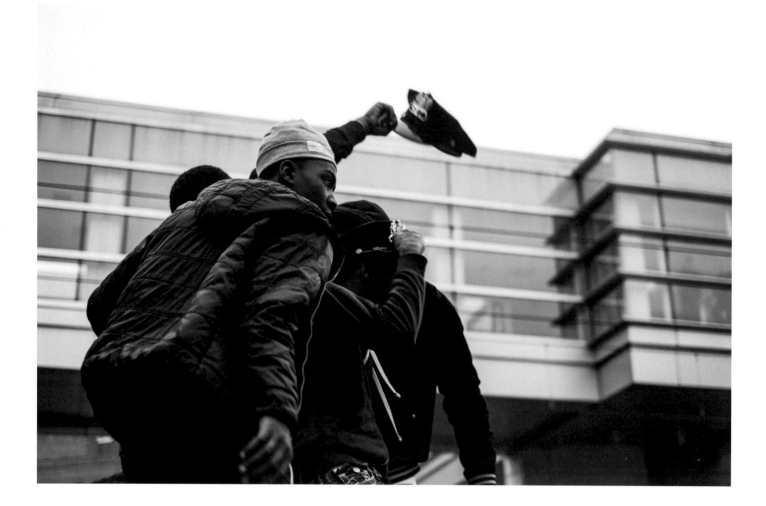

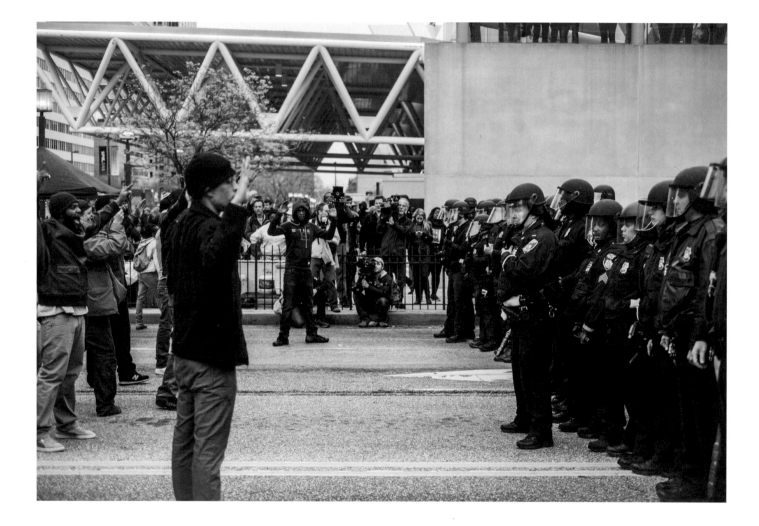

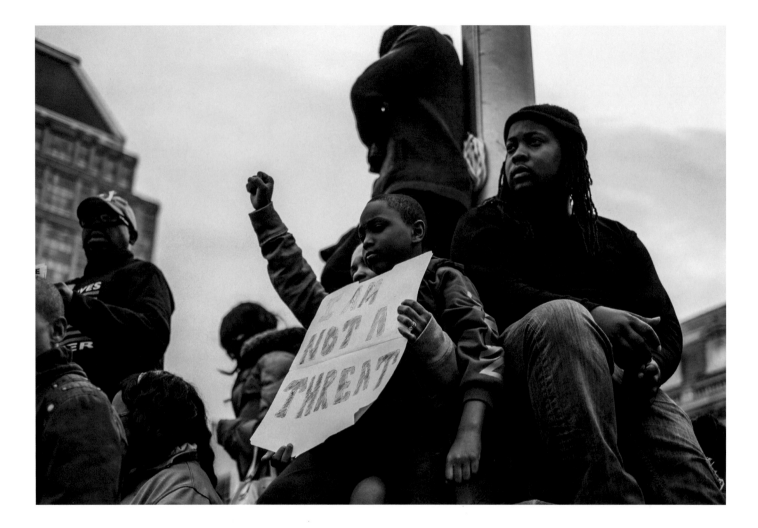

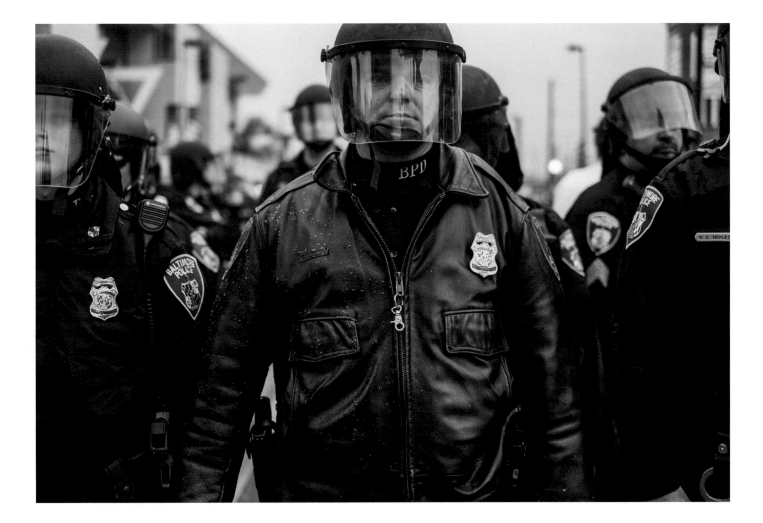

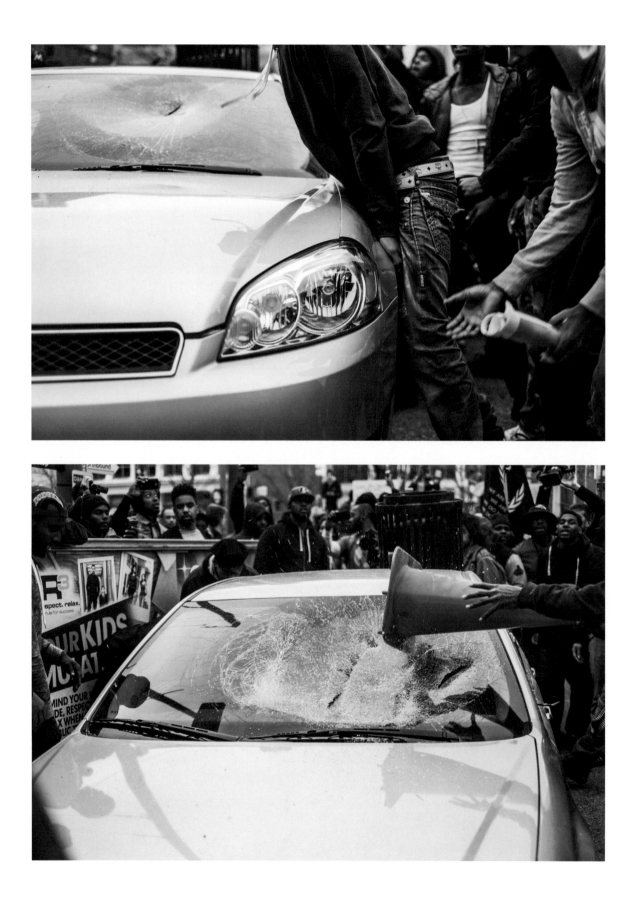

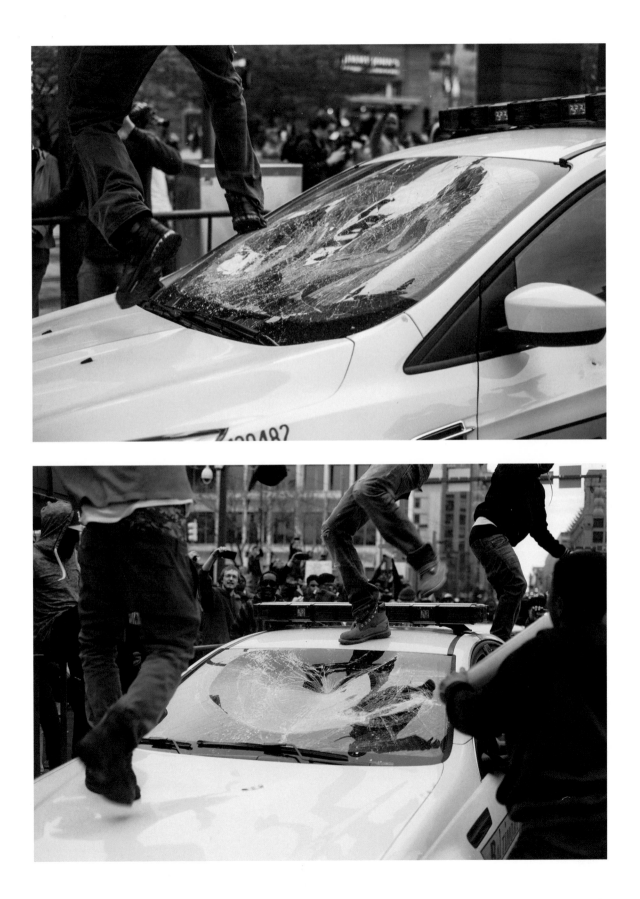

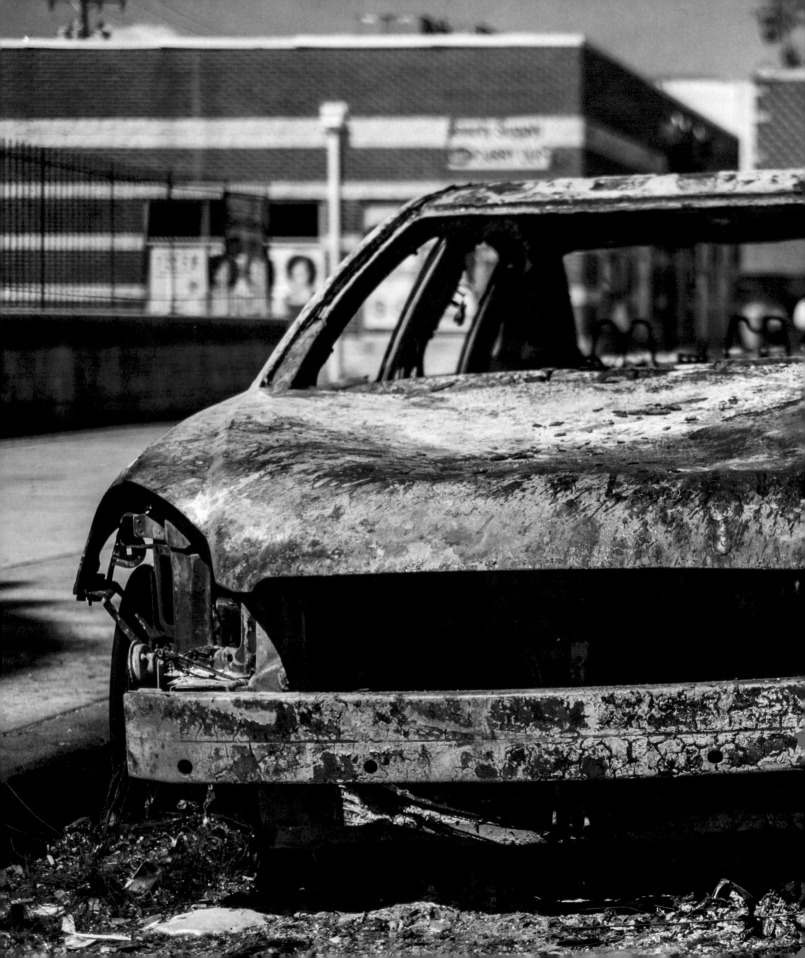

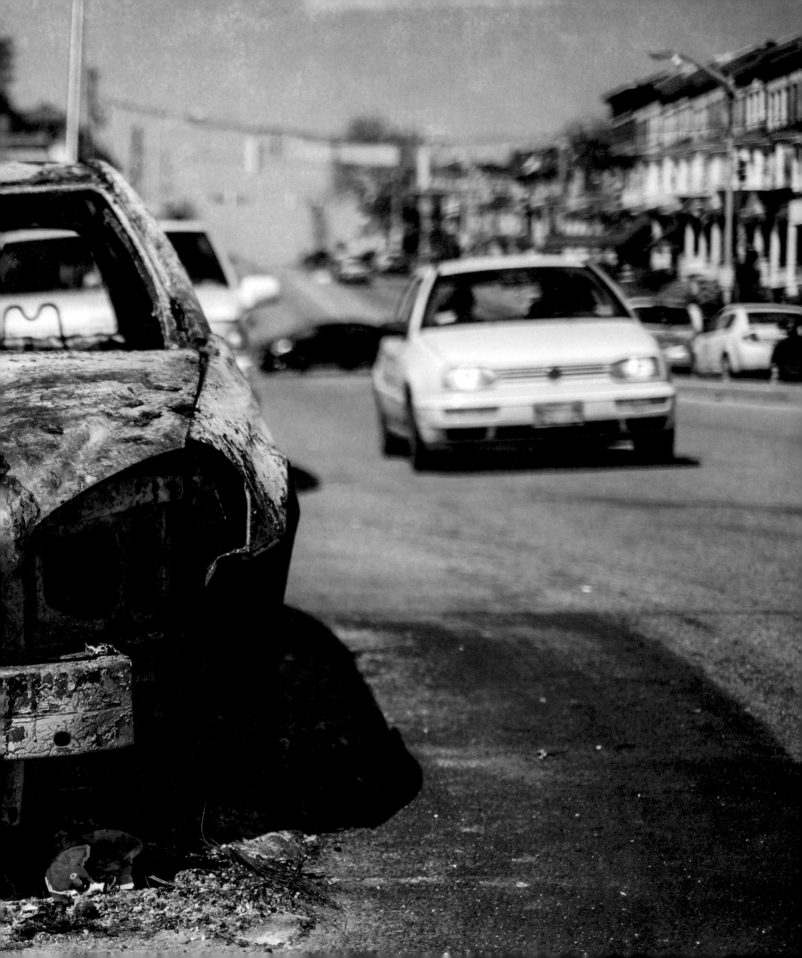

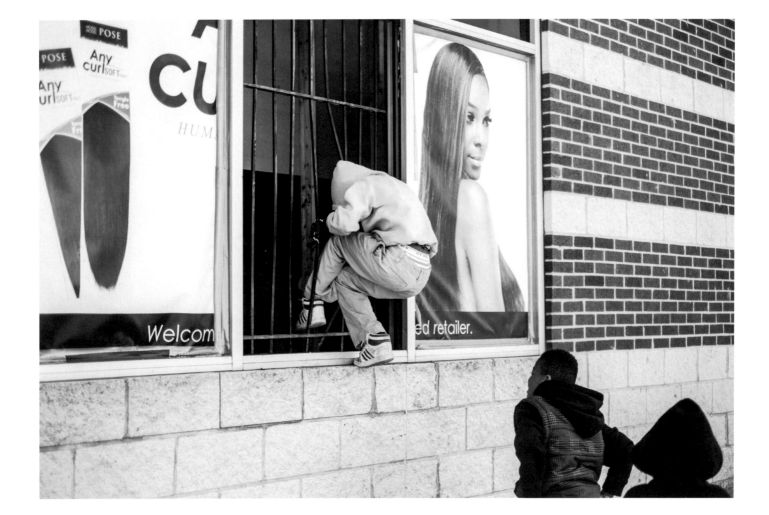

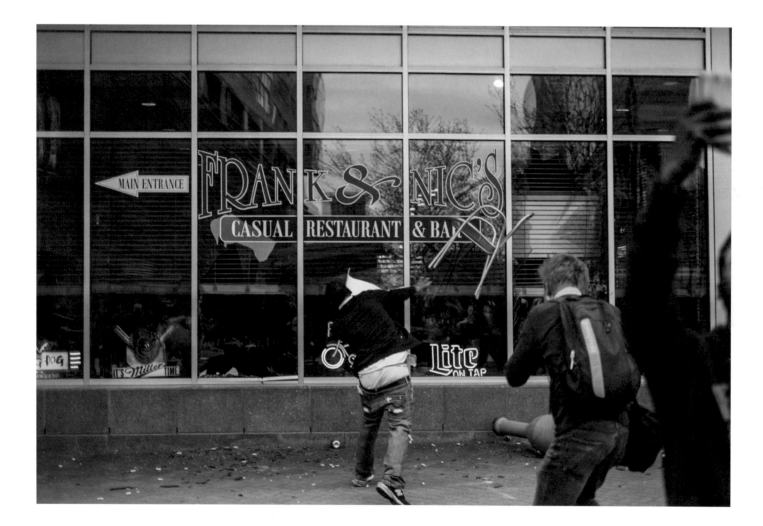

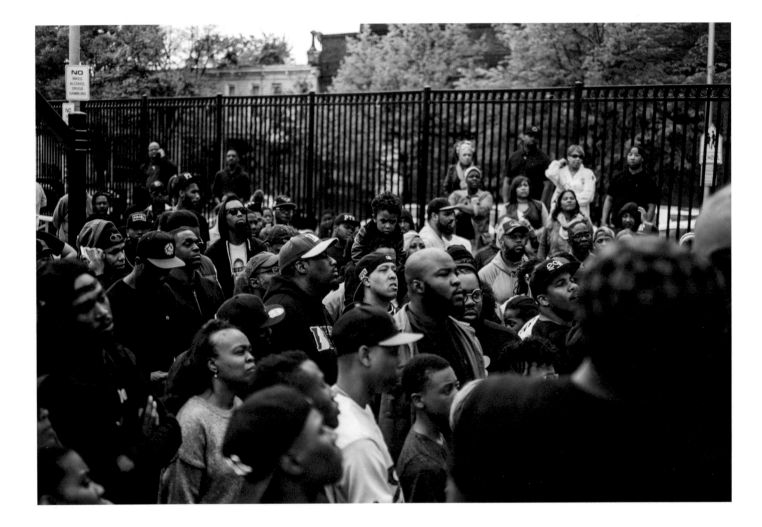

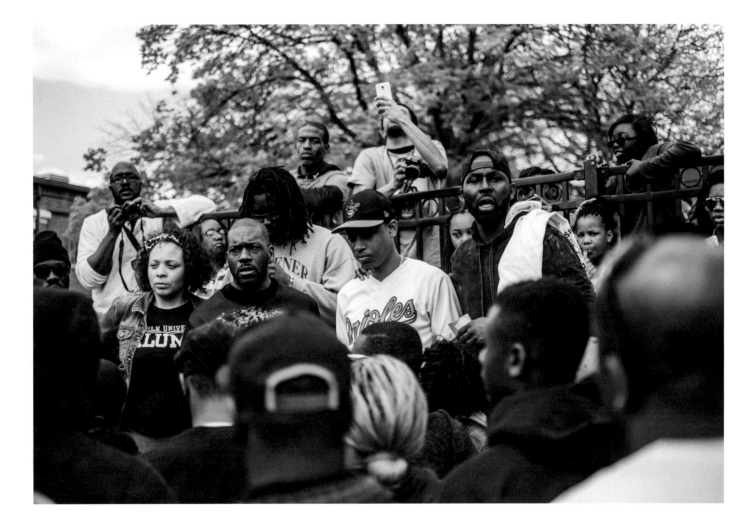

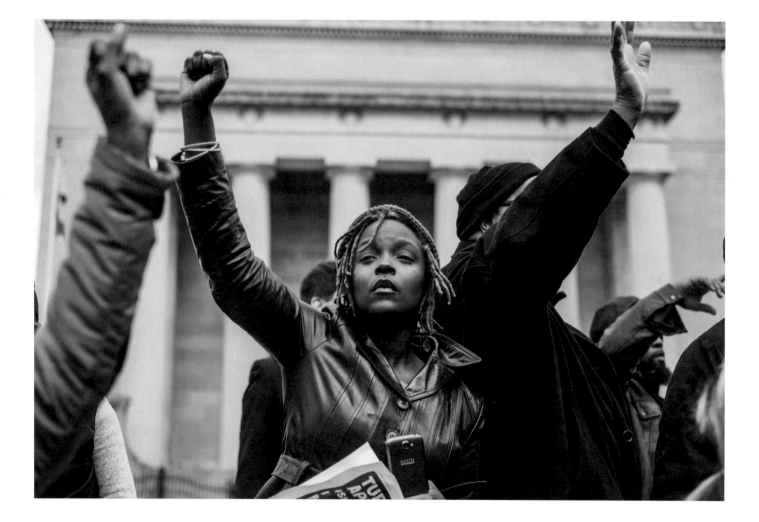

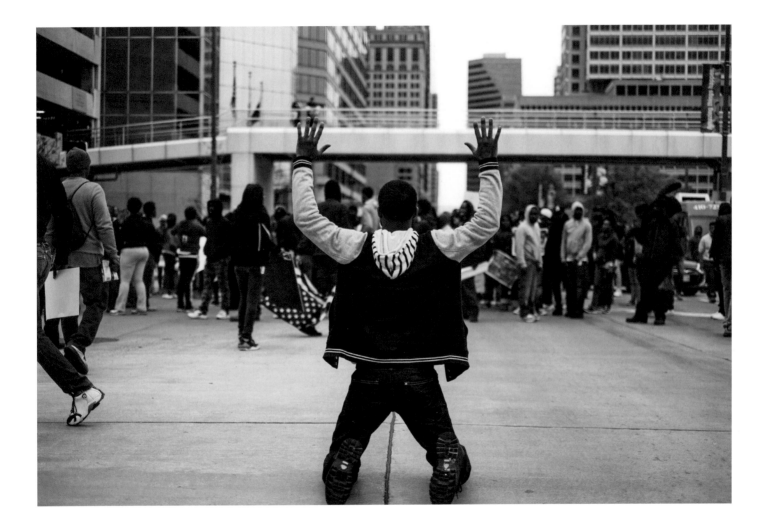

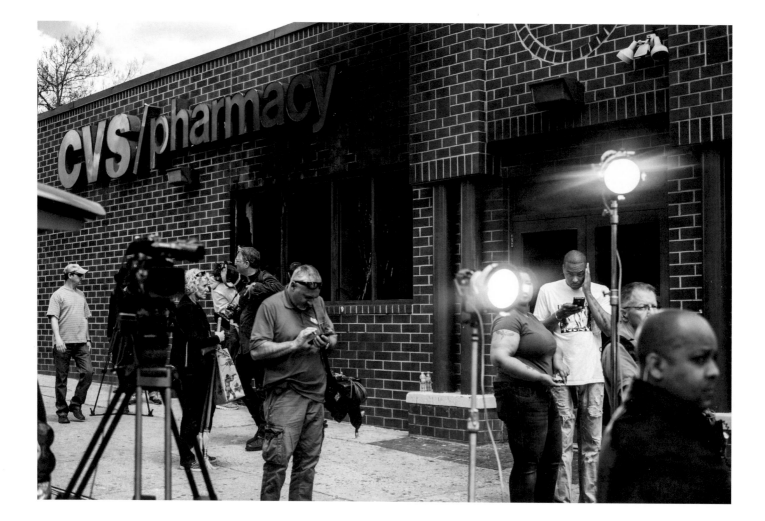

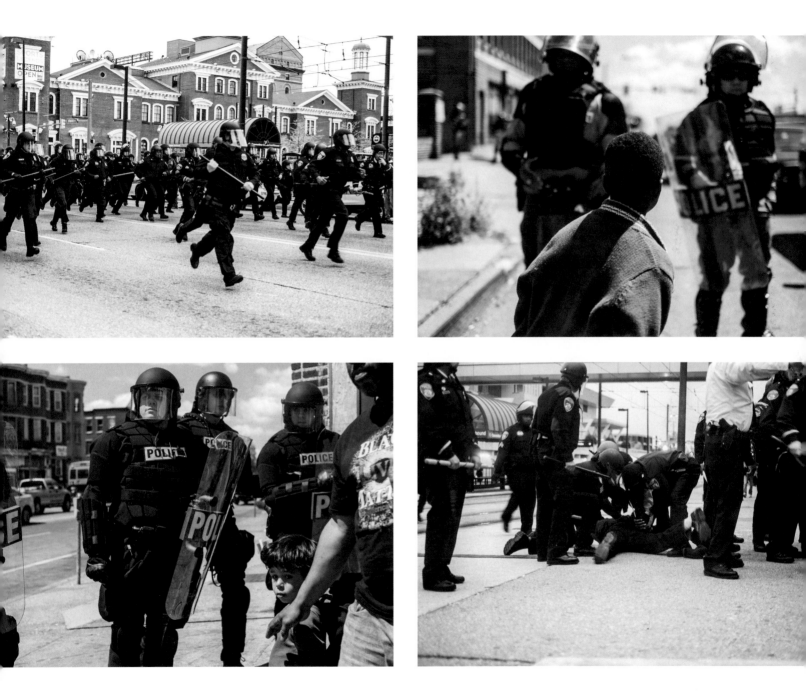

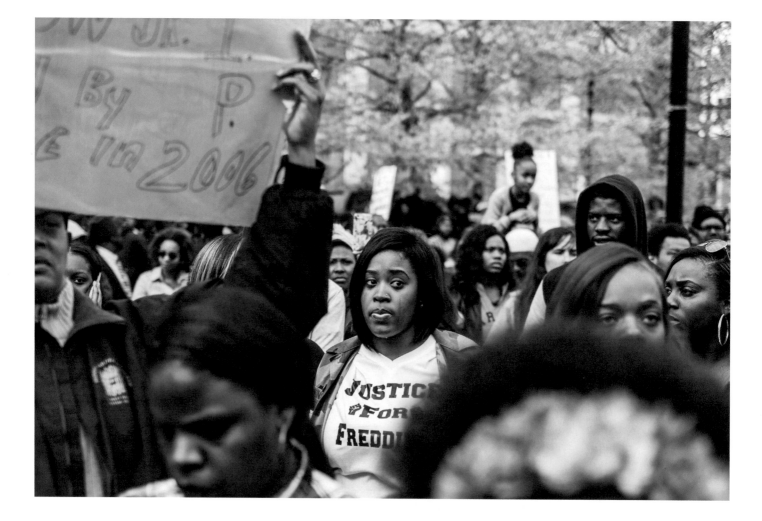

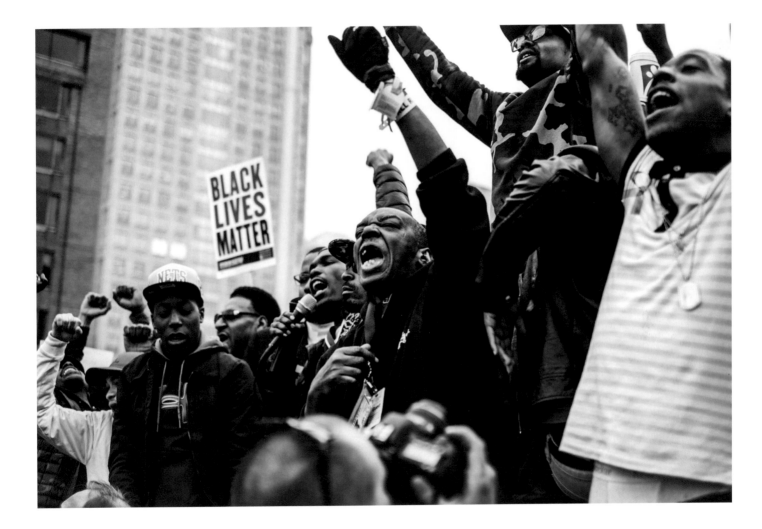

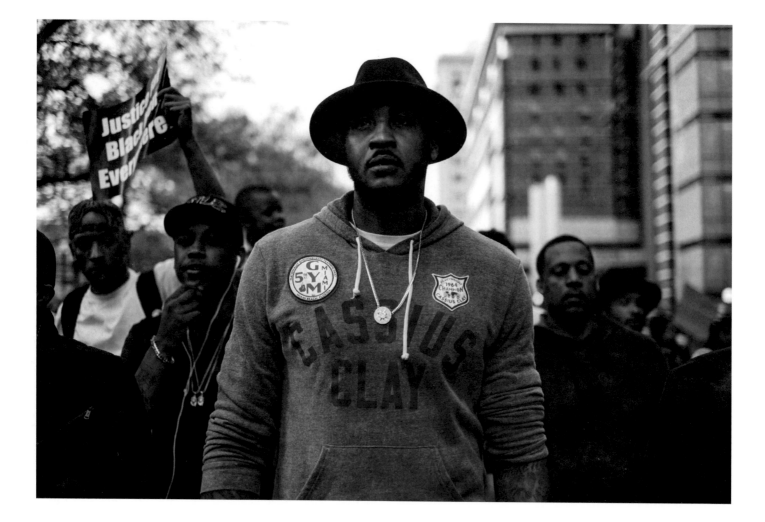

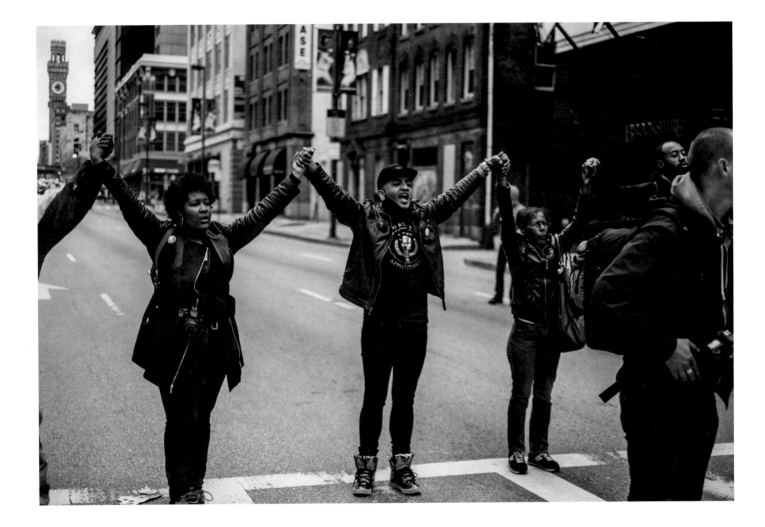

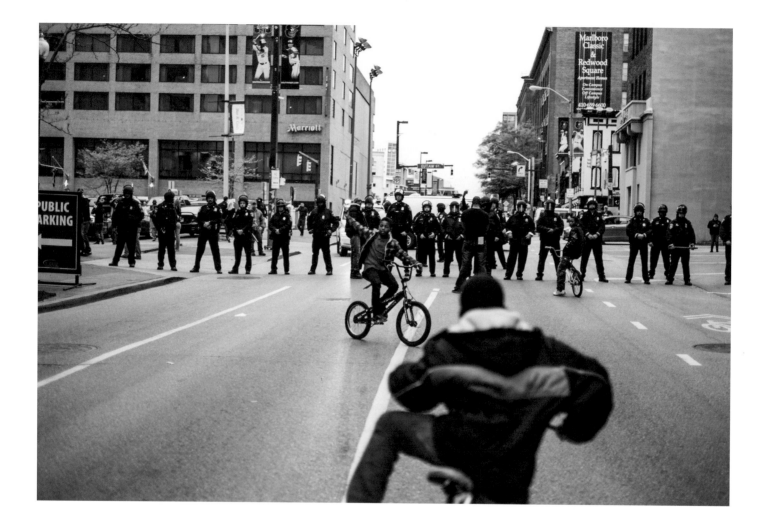

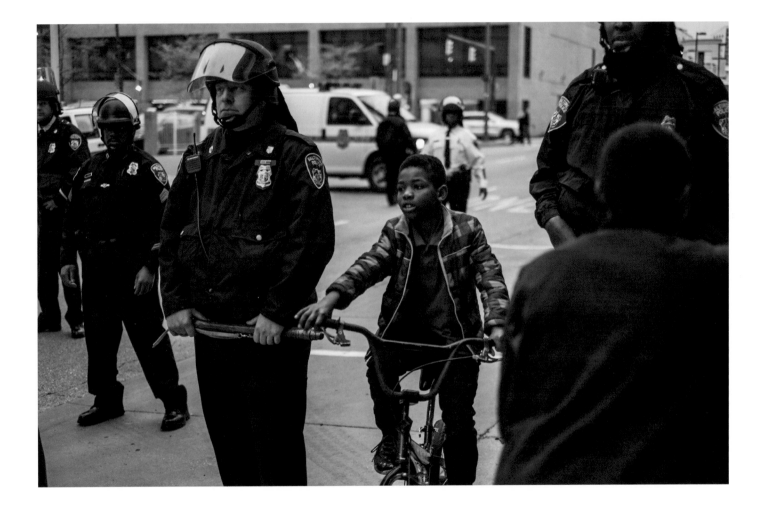

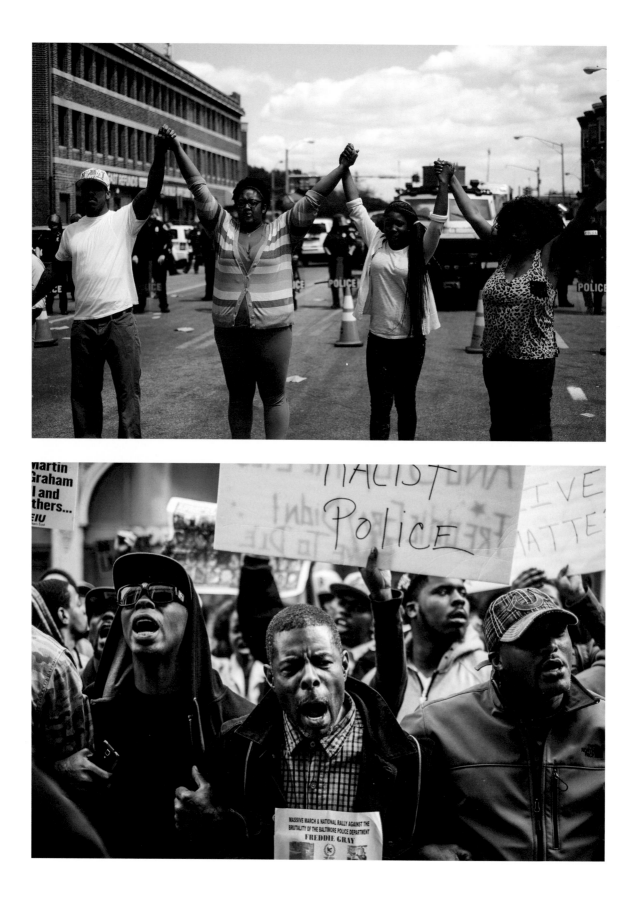

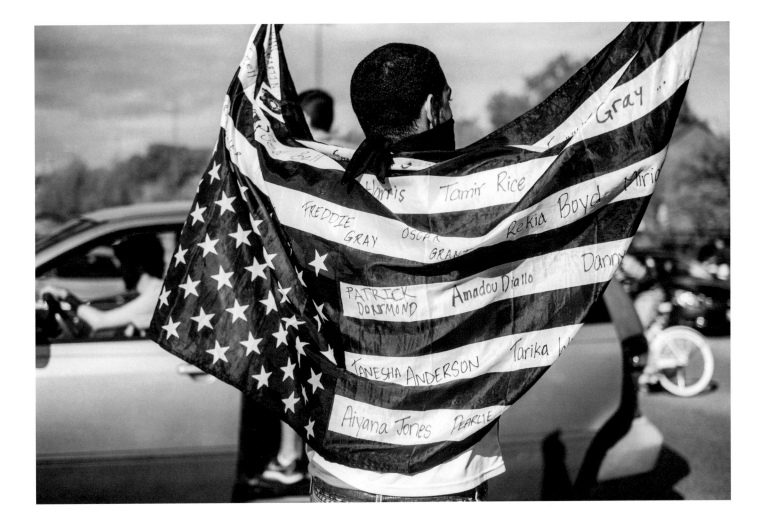

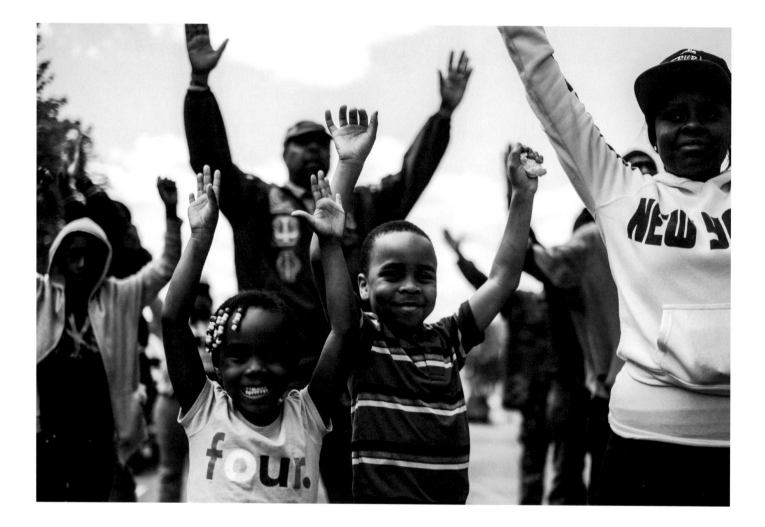

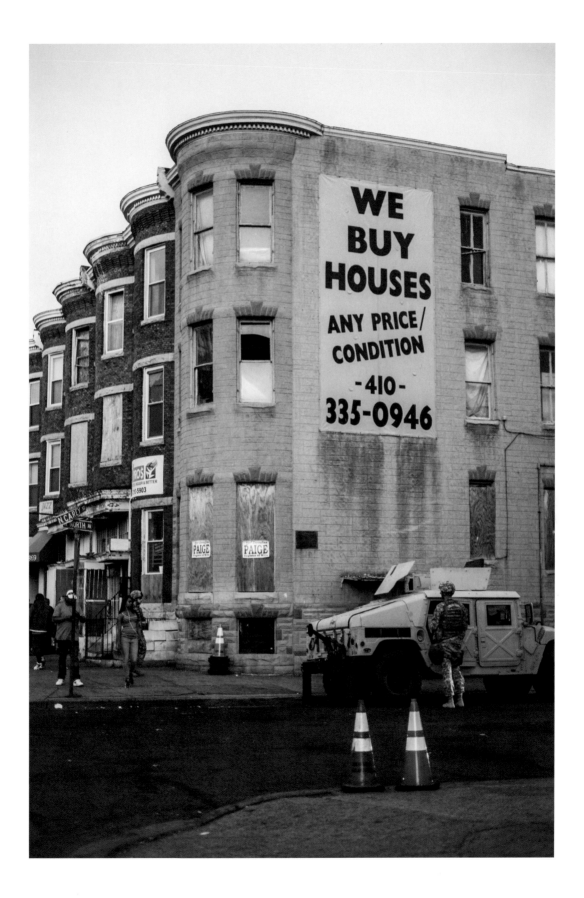

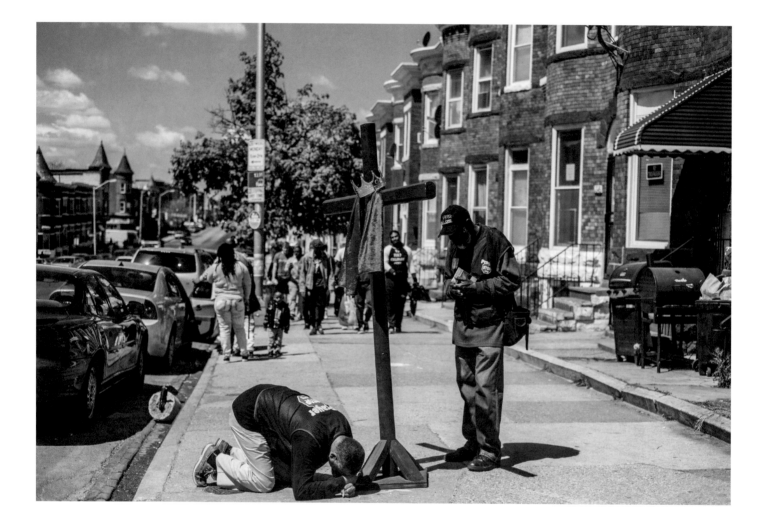

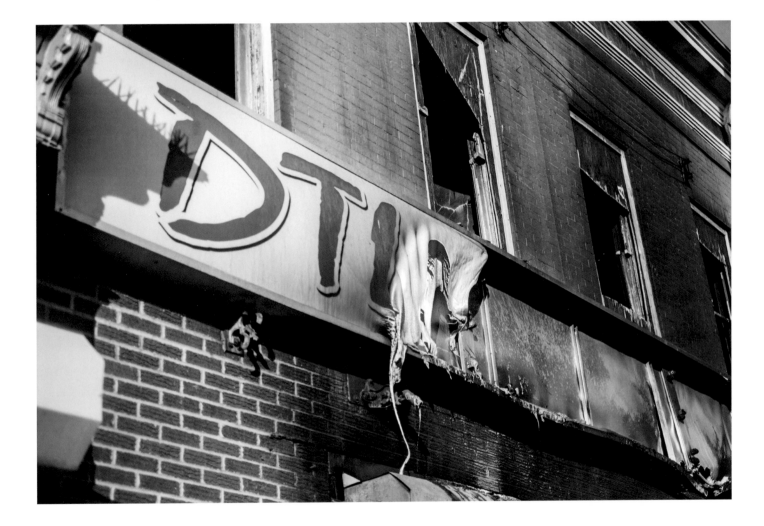

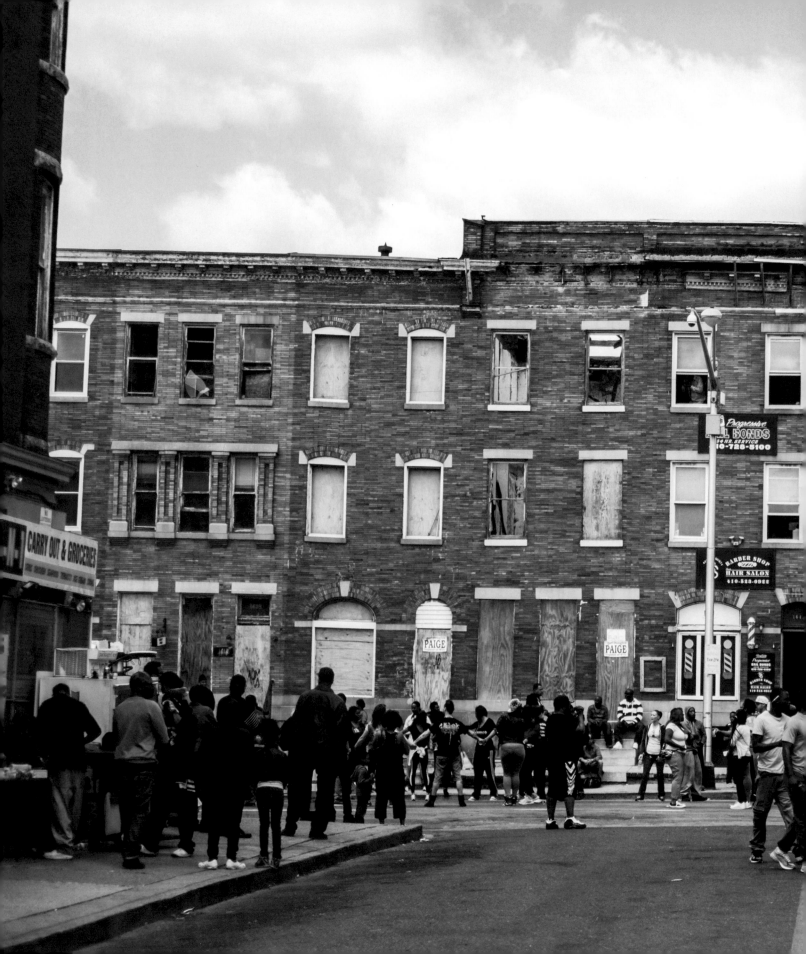

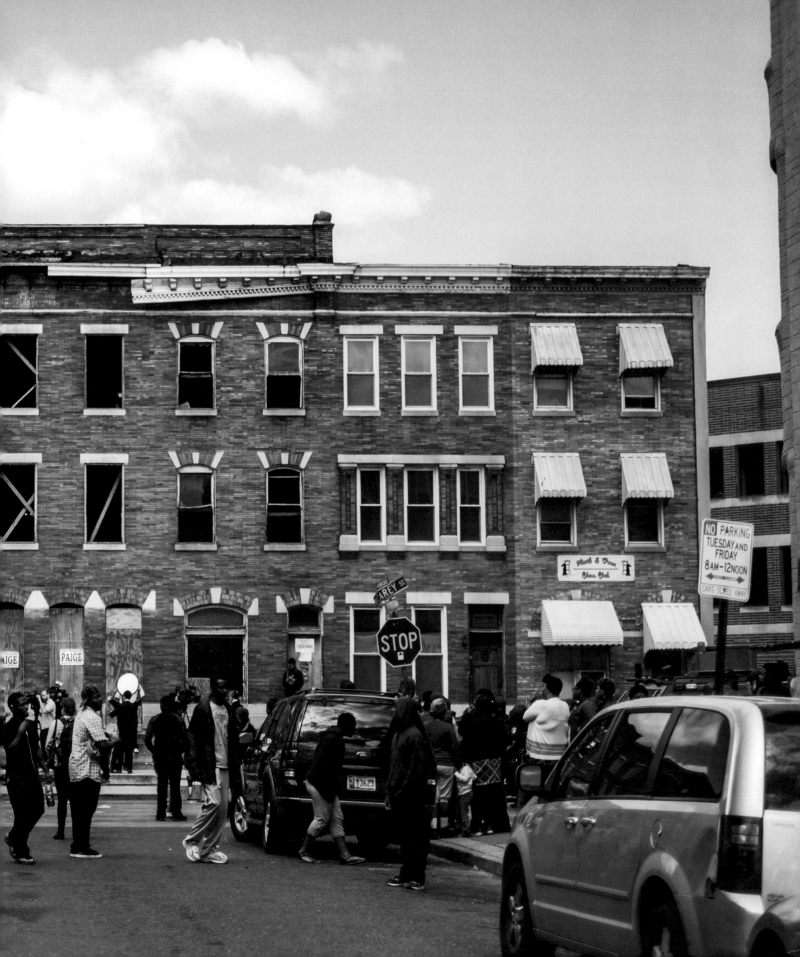

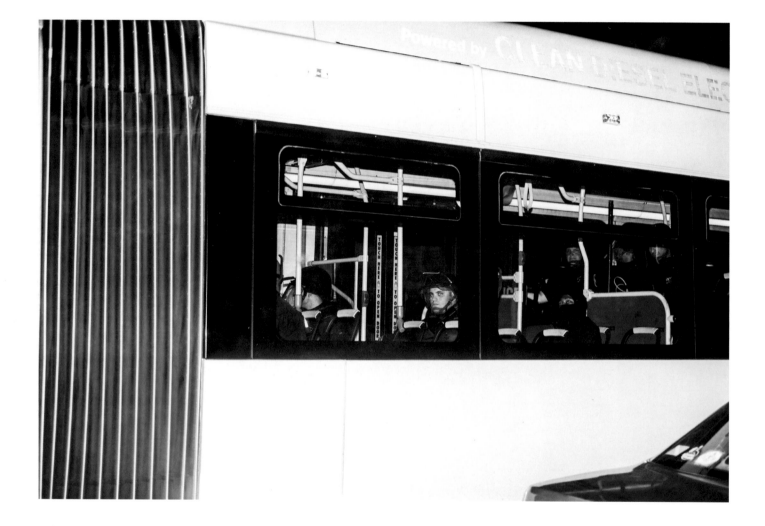

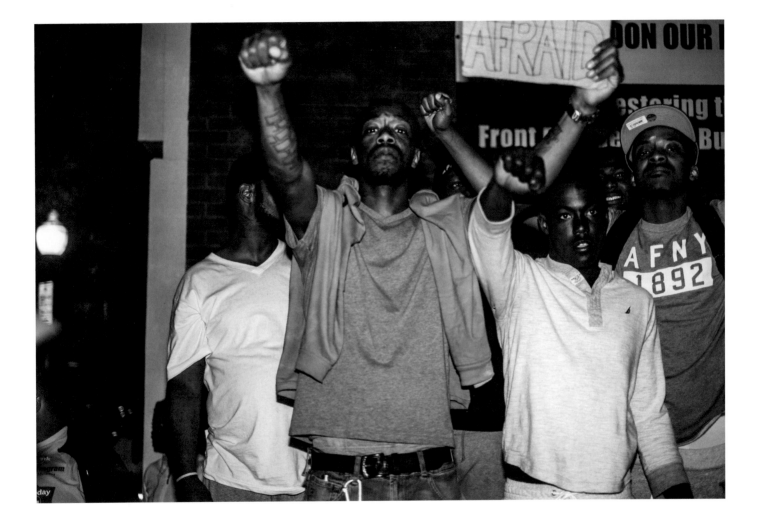

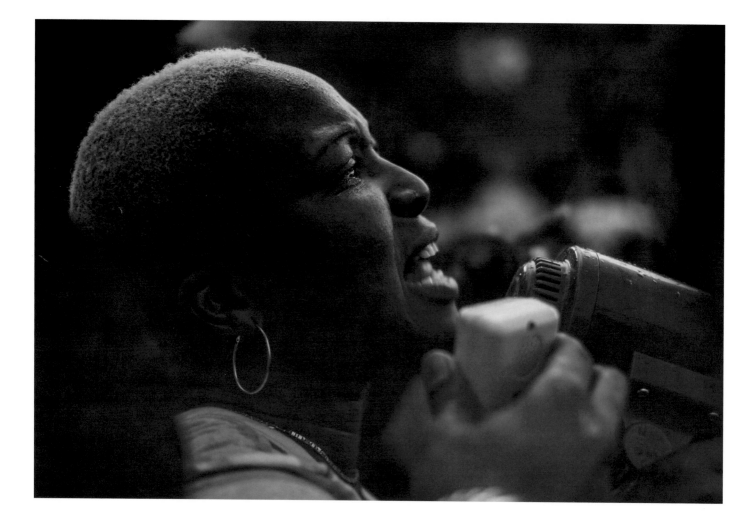

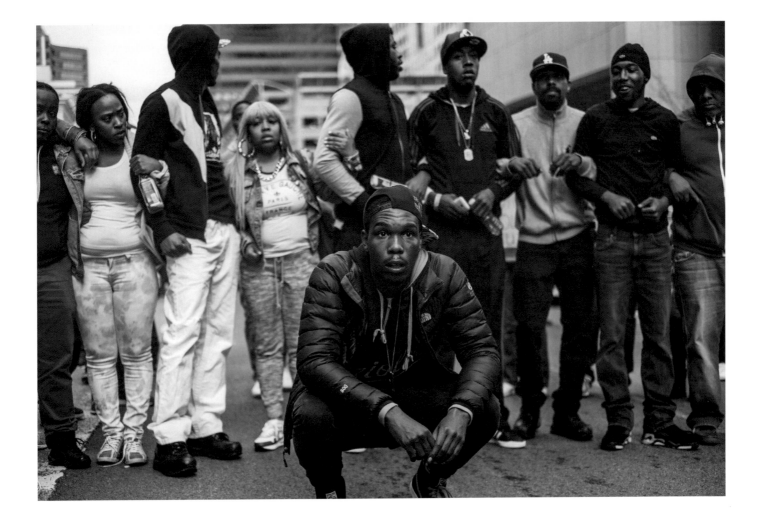

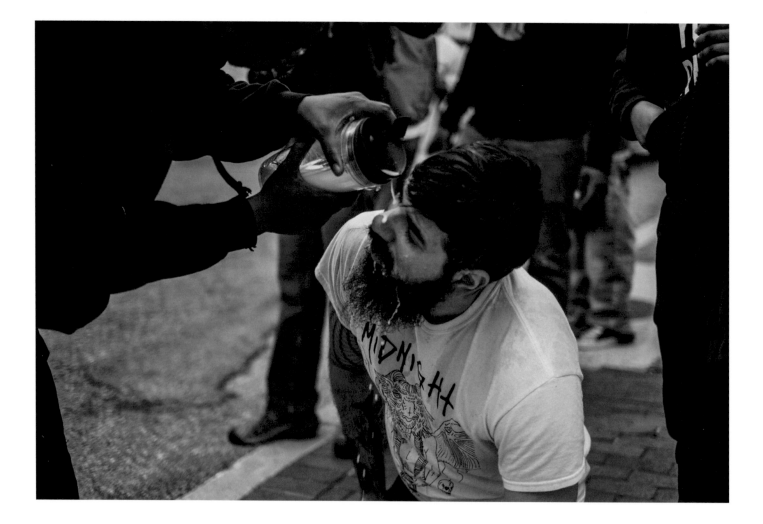

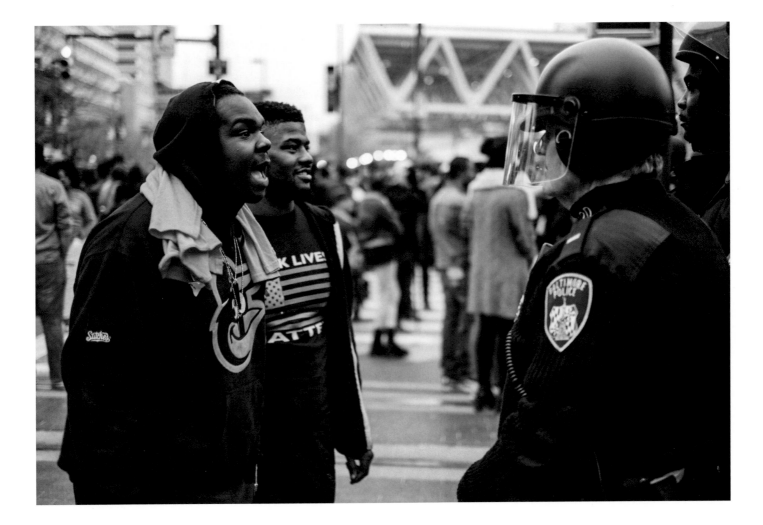

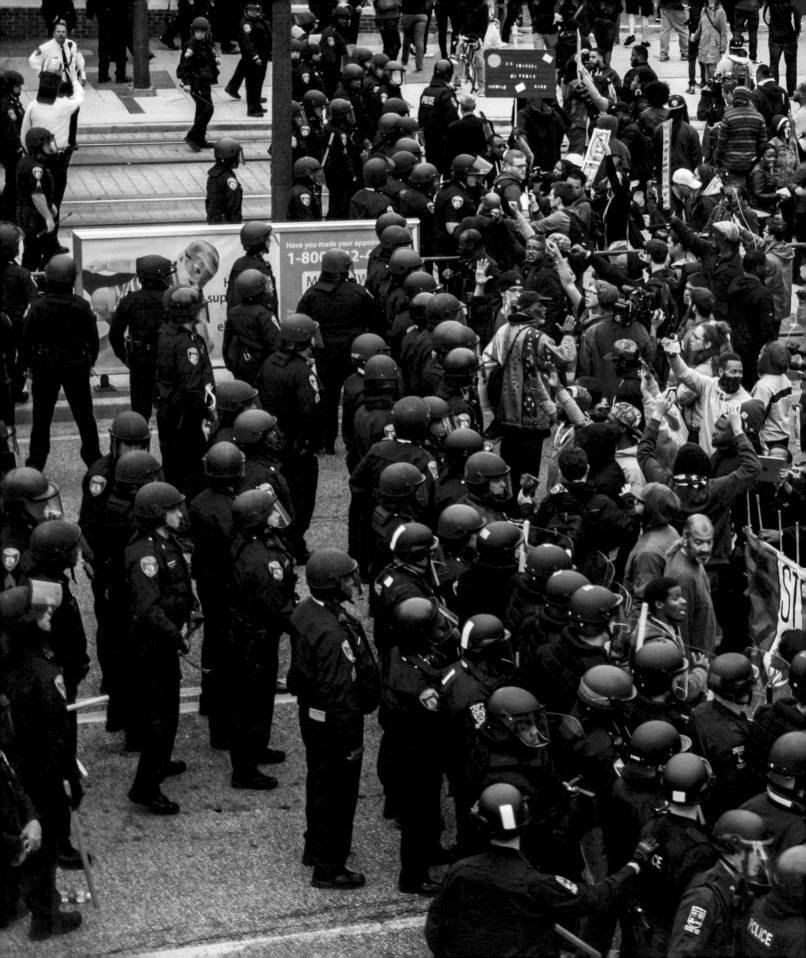

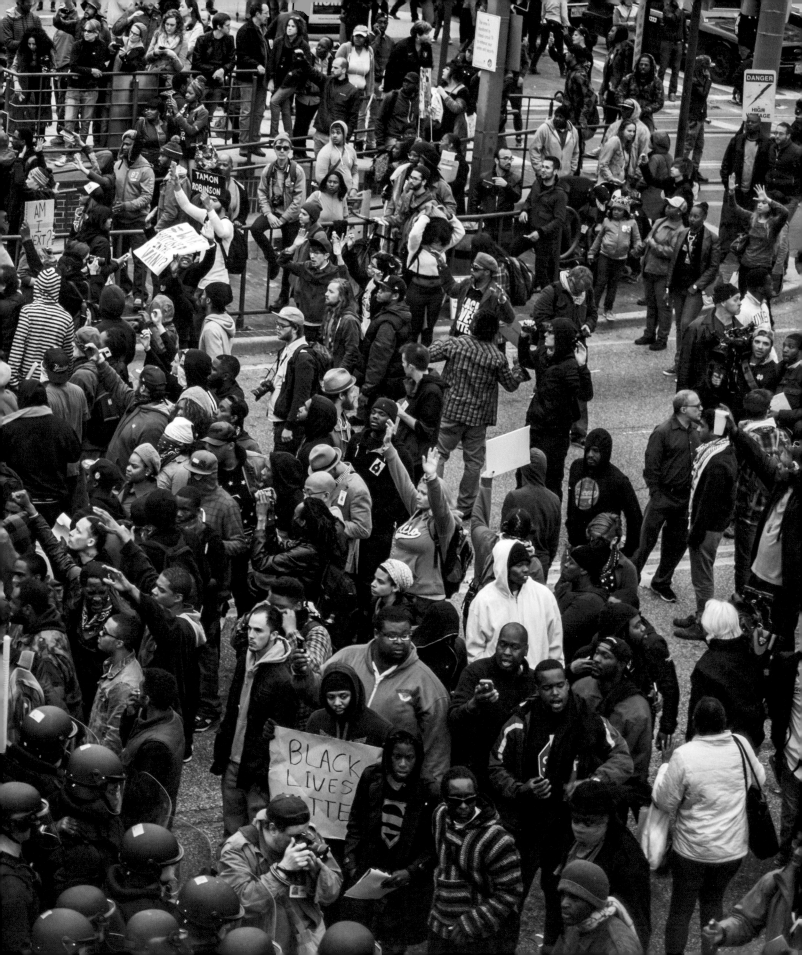

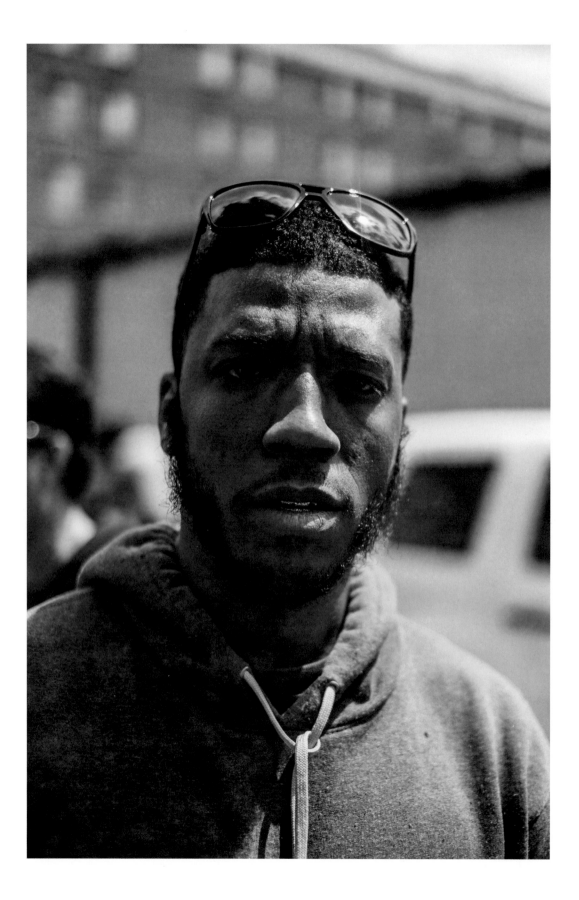

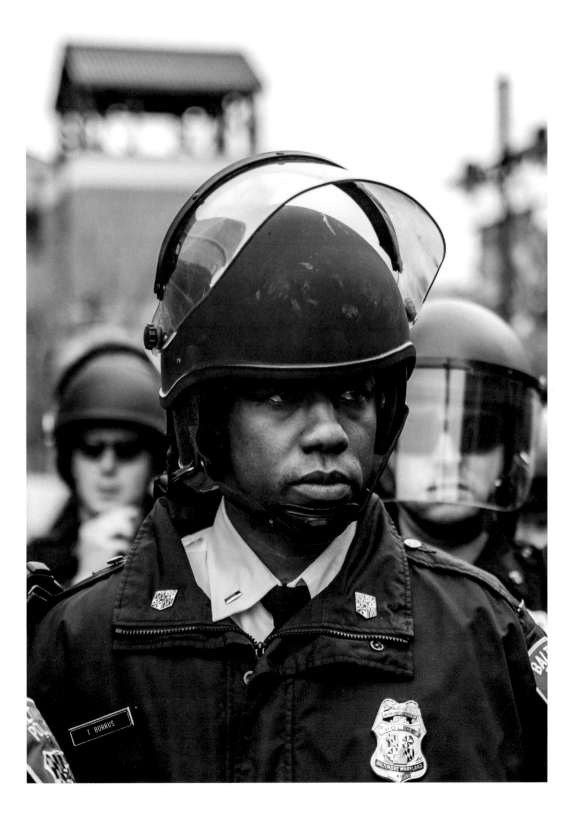

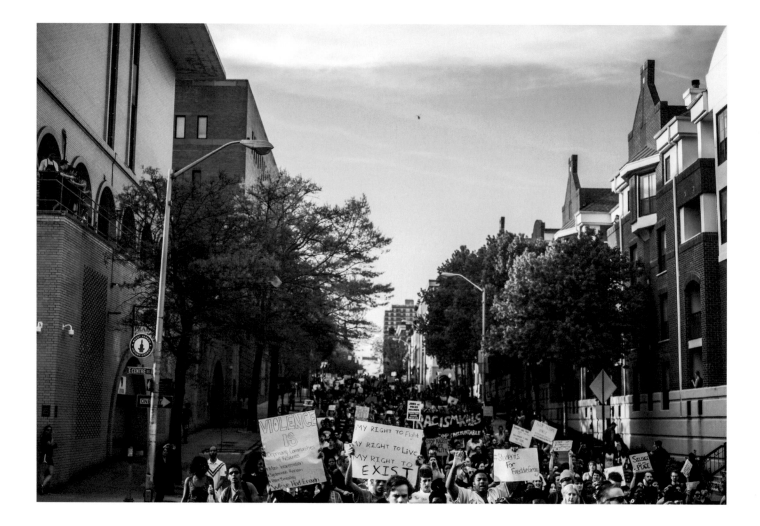

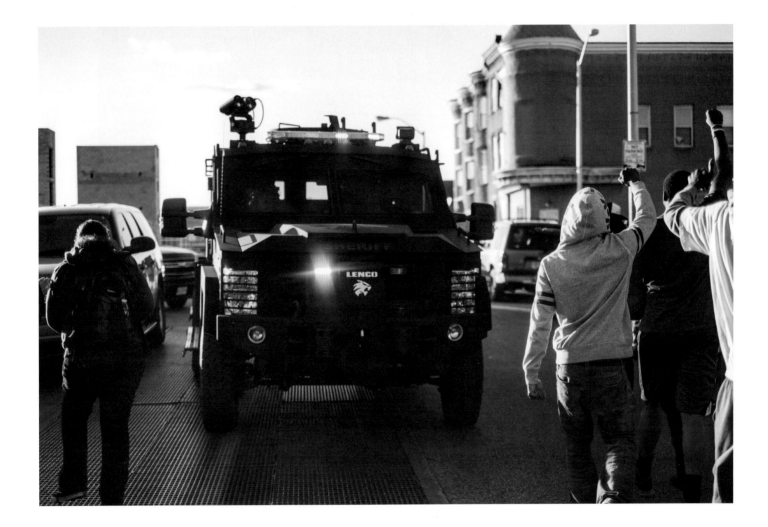

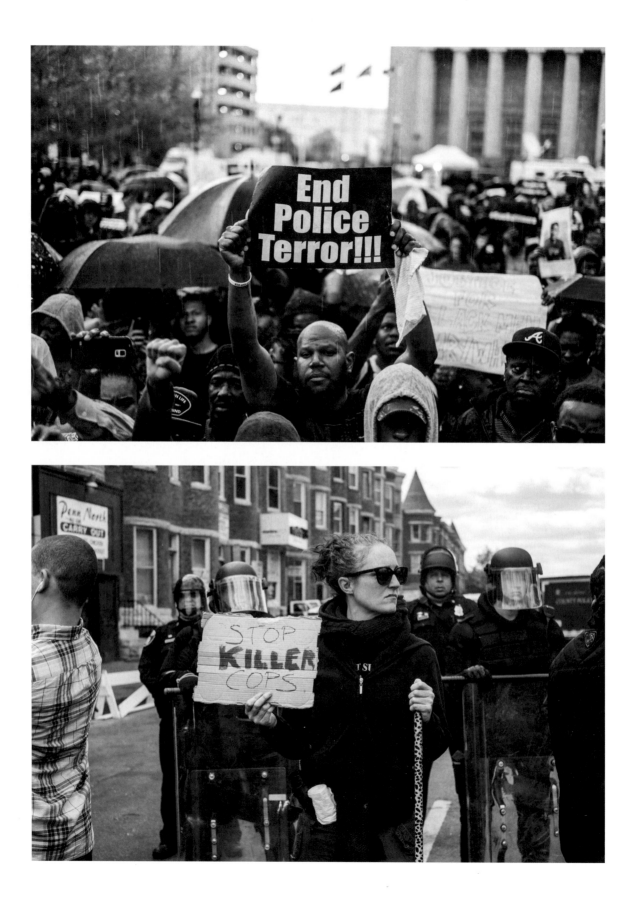

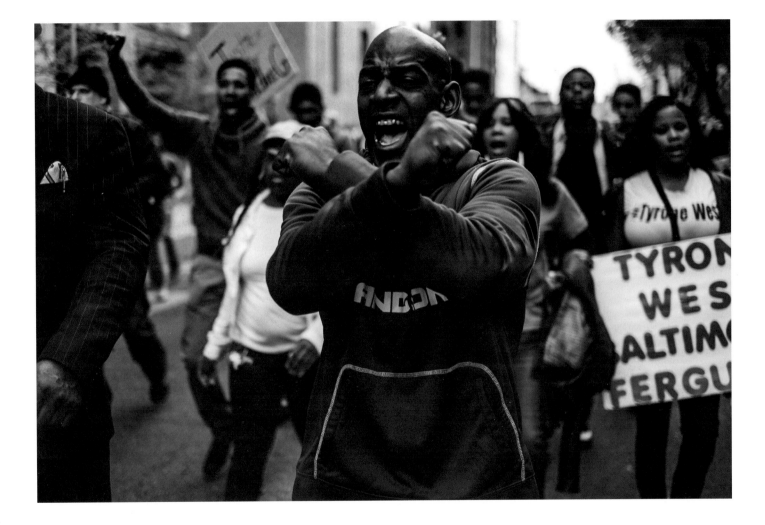

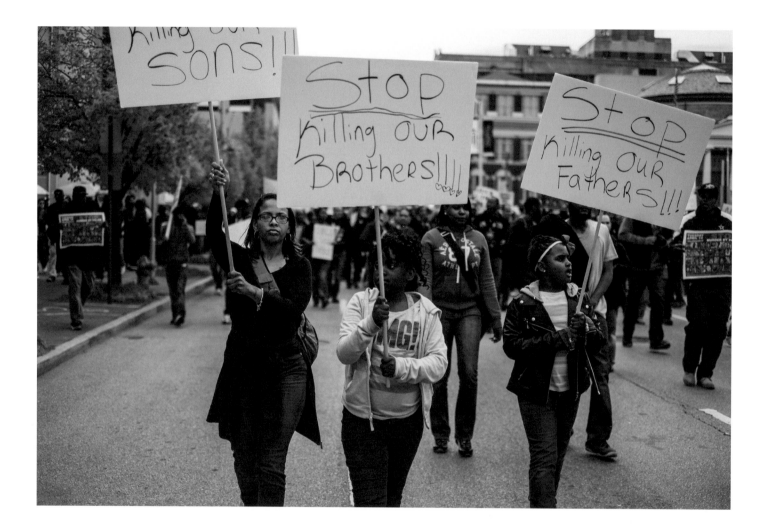

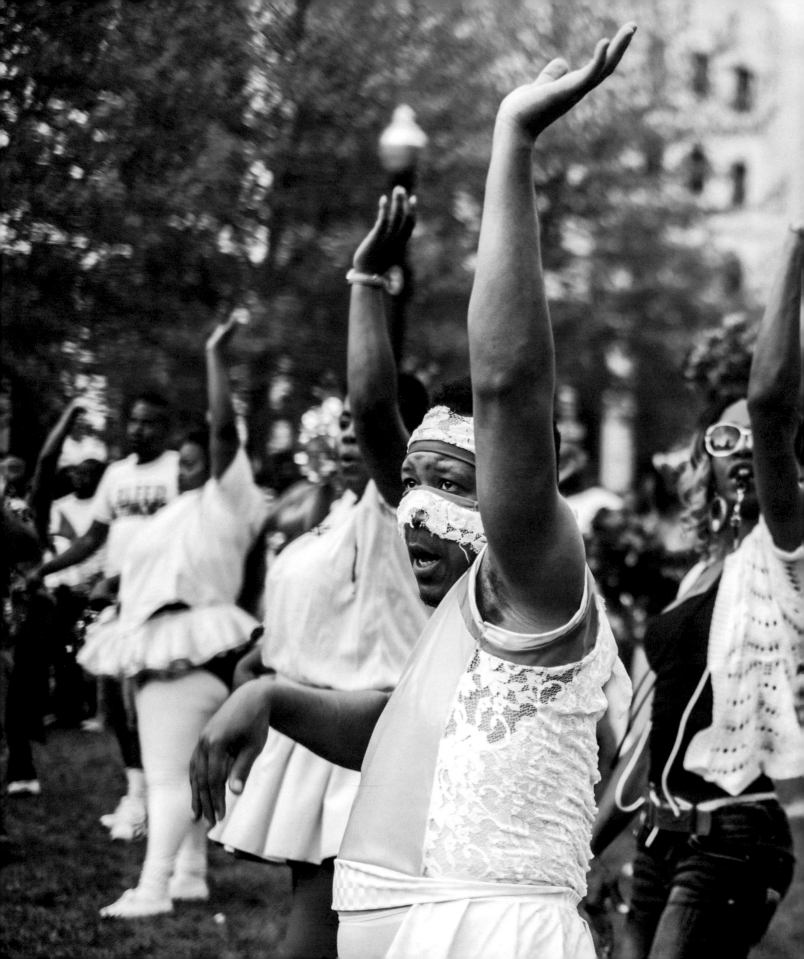

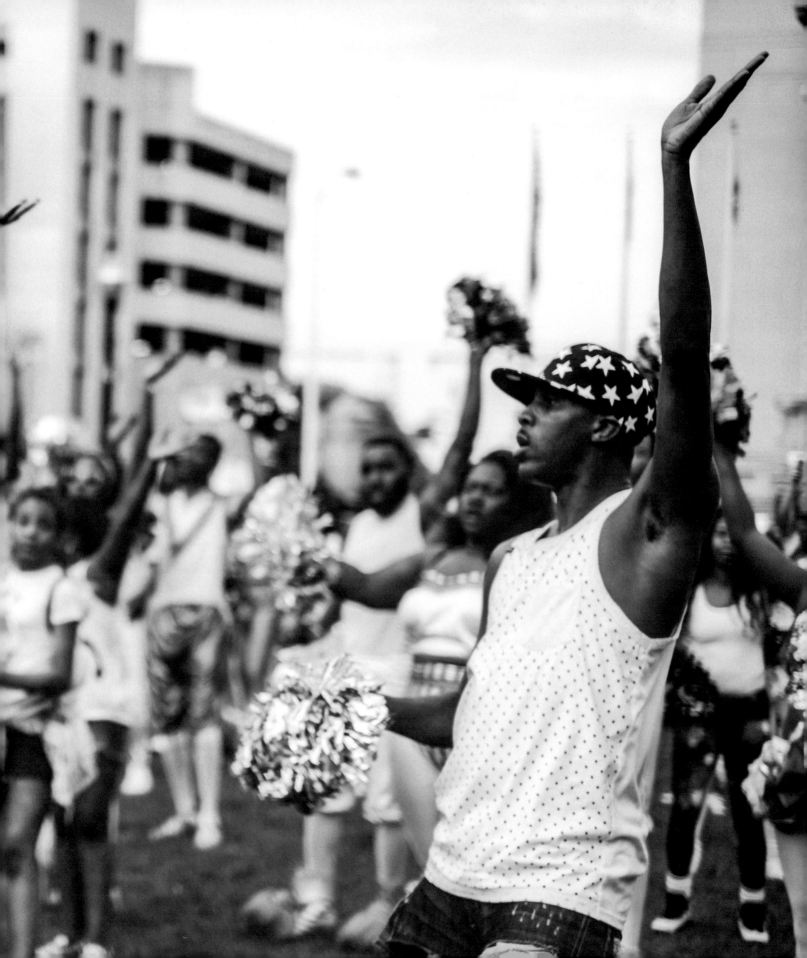

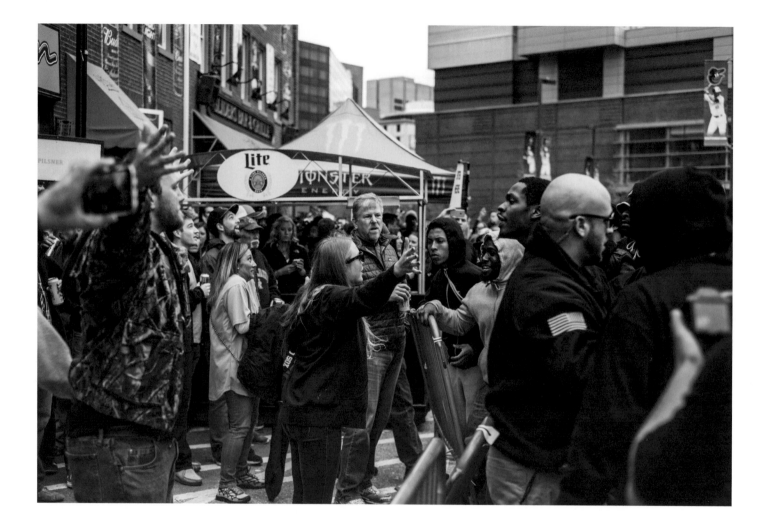

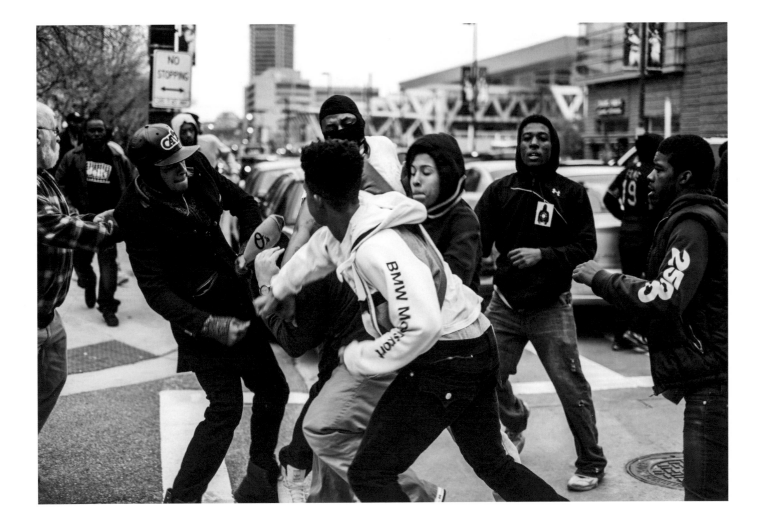

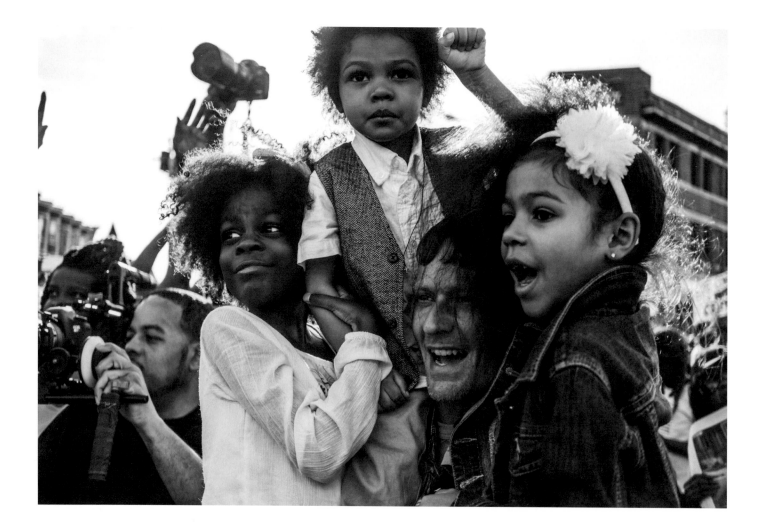

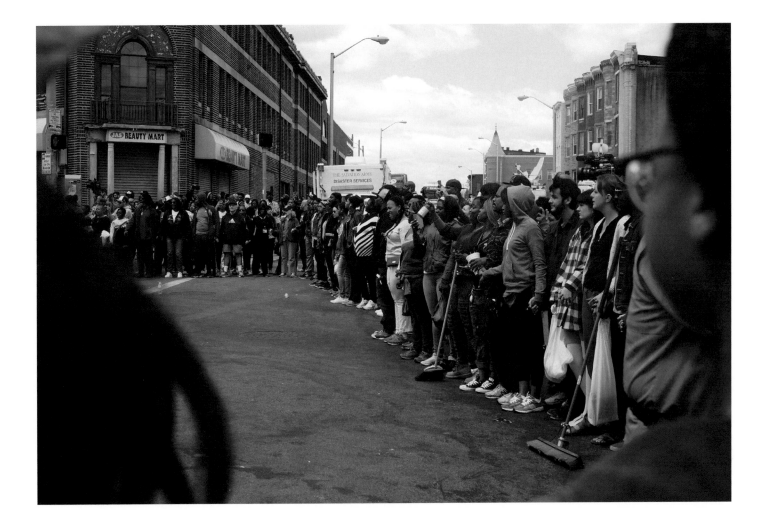

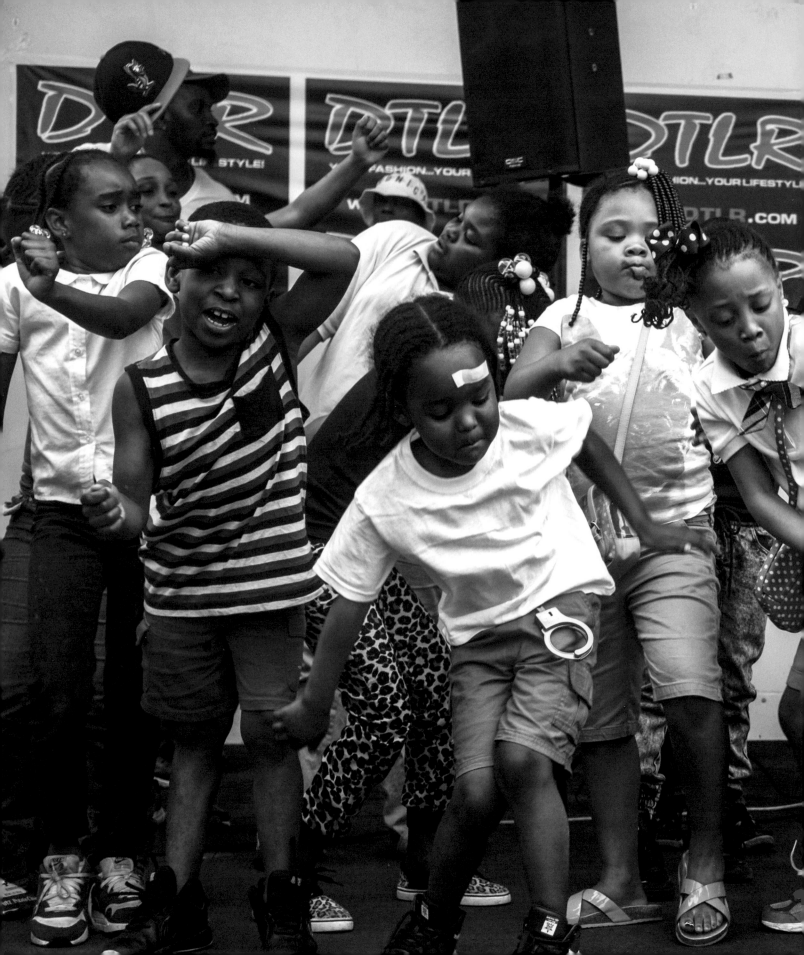

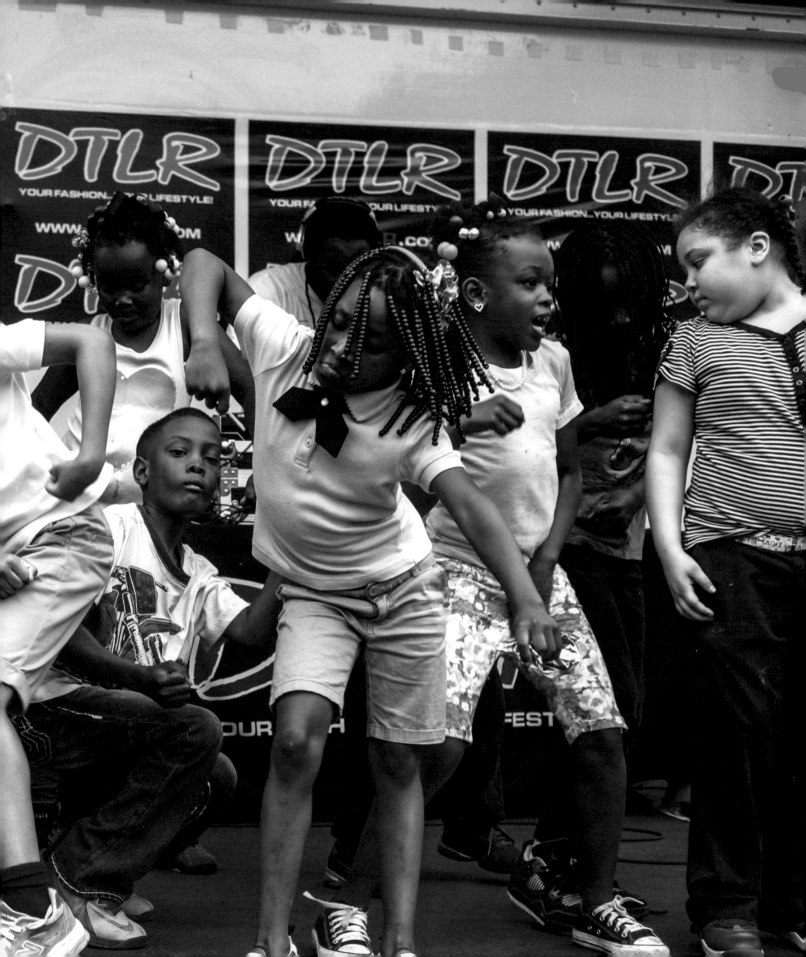

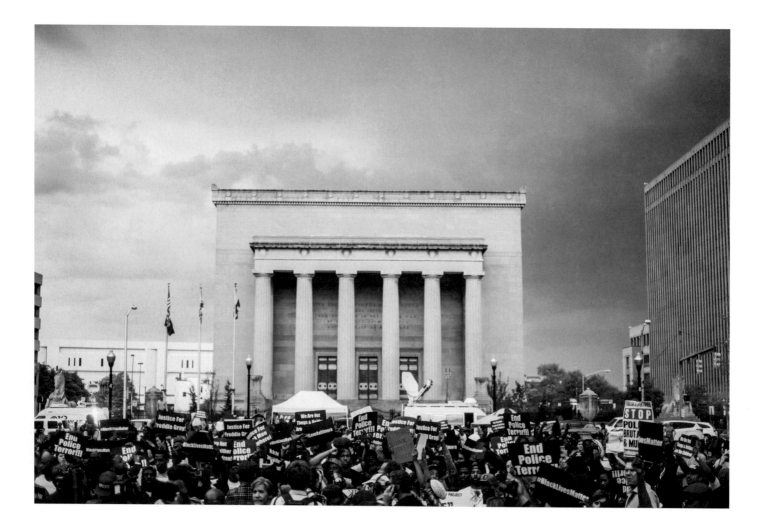

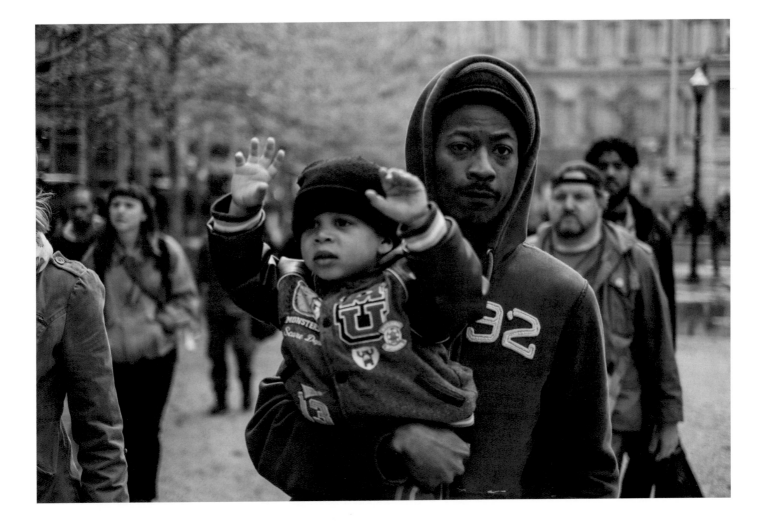

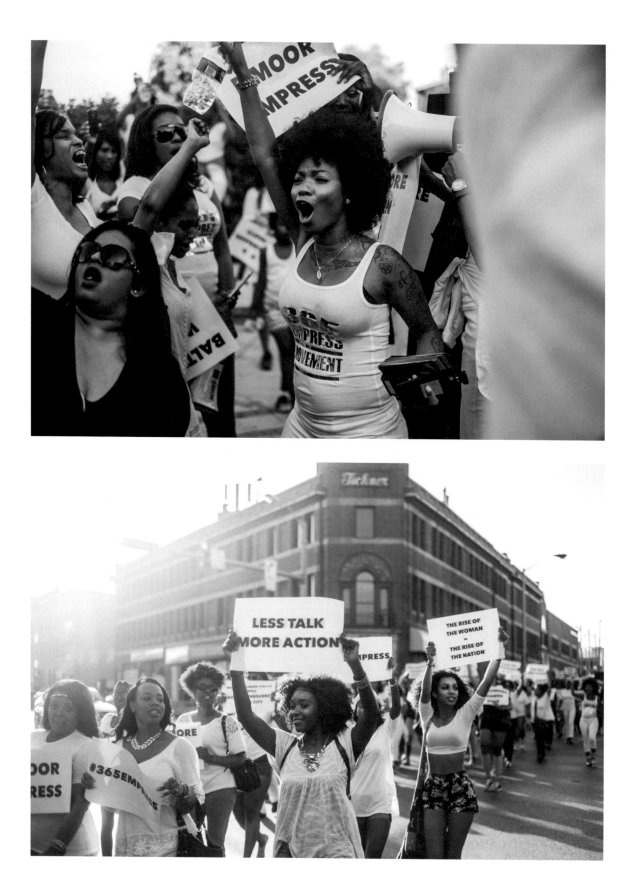

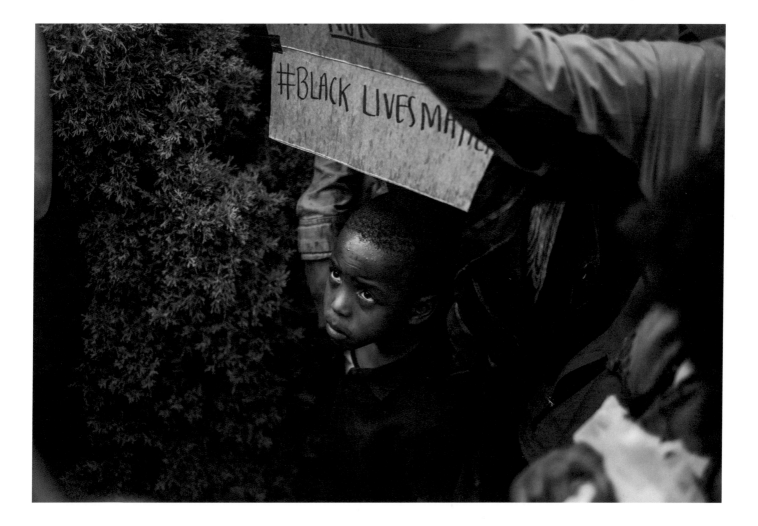

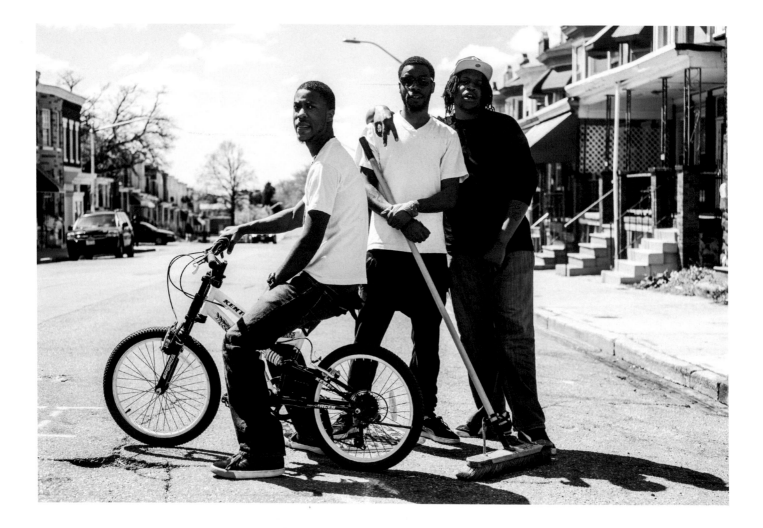

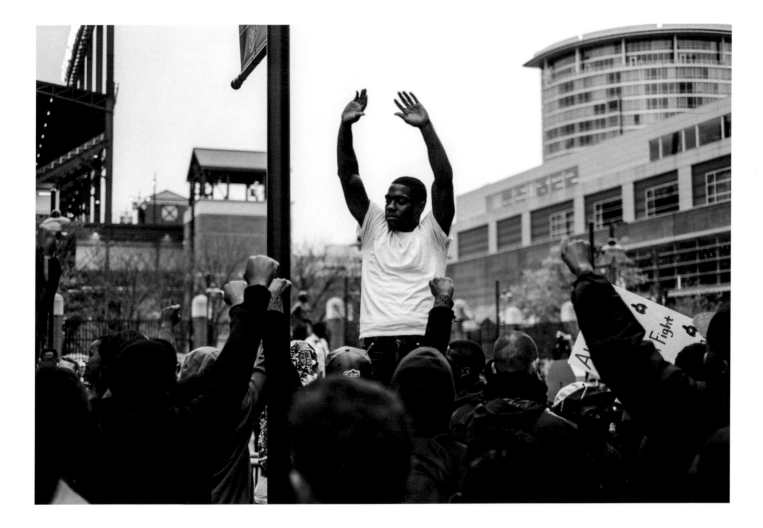

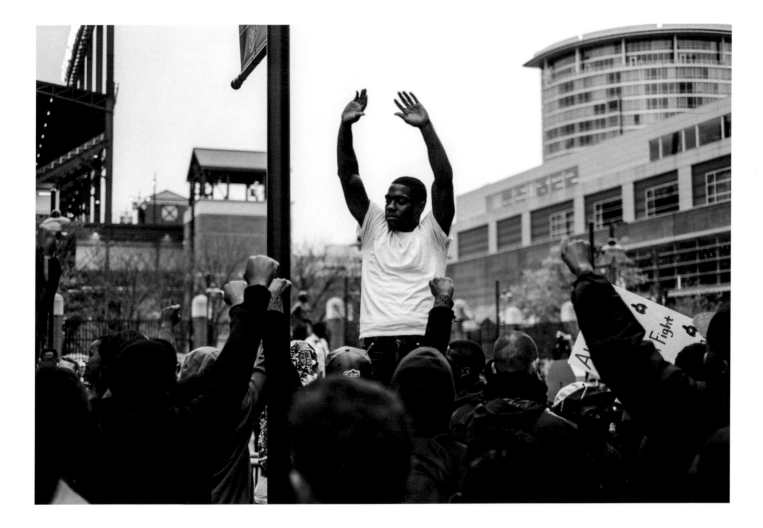

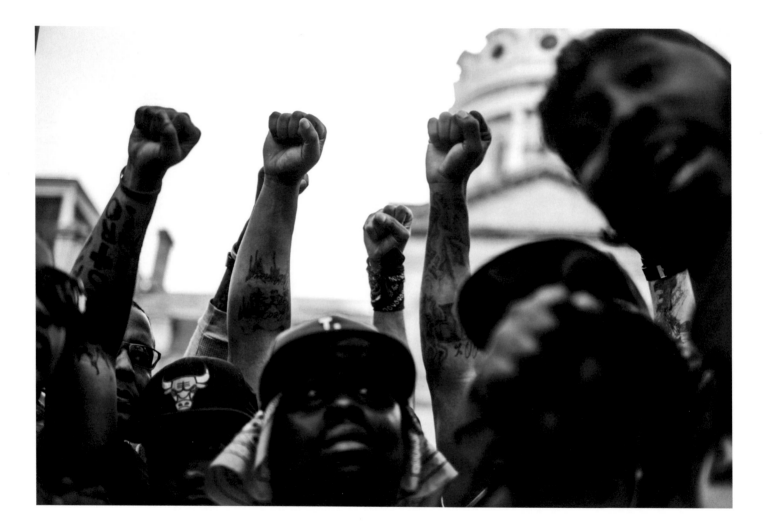

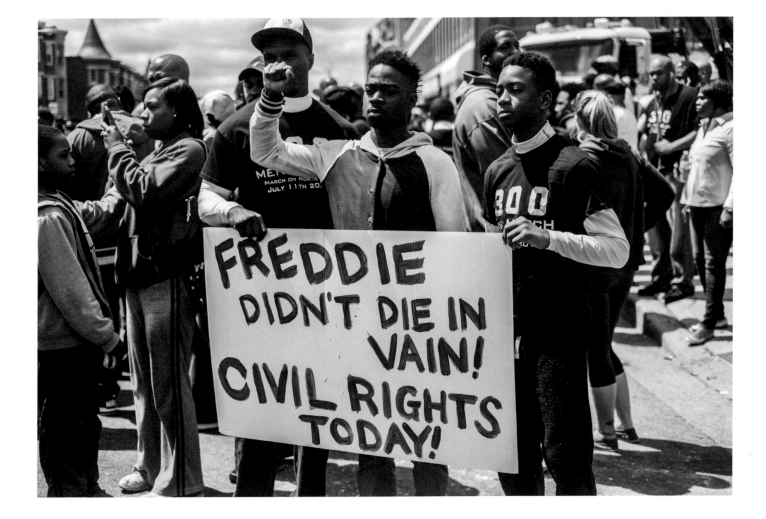

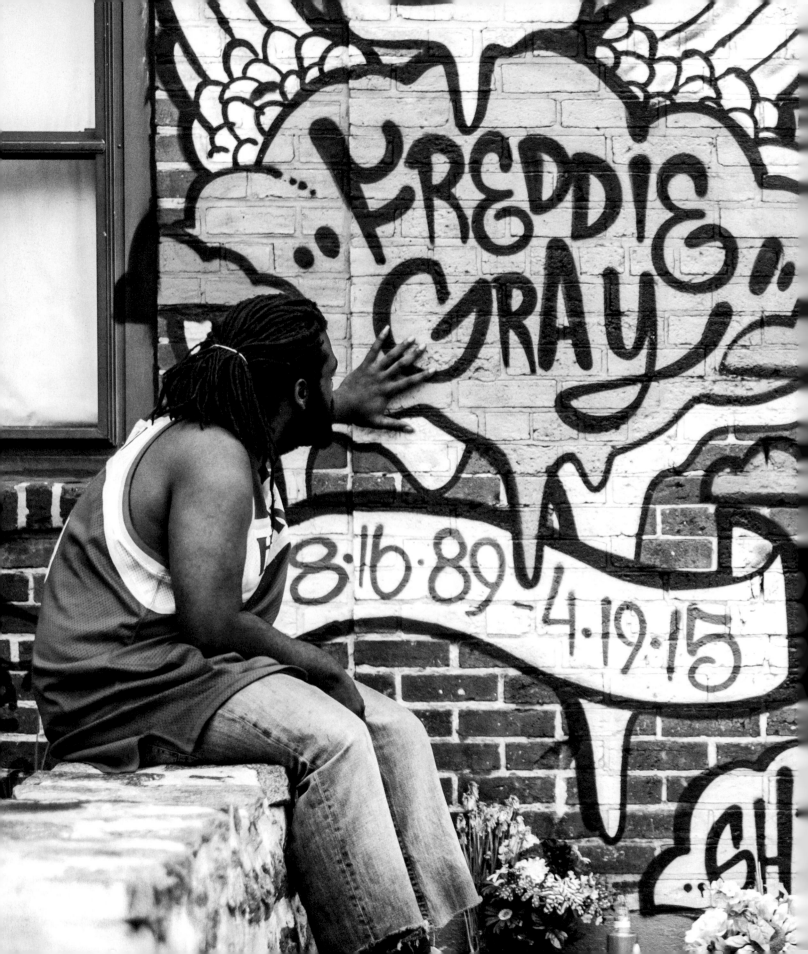

APRIL 27TH

I looked Freddie in the eye today
and watched infants drenched in the placenta of revolution
stream down from his tear ducts, cascade onto the cement,
and roll in the crevices of the sidewalk
I watched puffs of dirt bike smoke swim across his pupils
as the two-wheeled Lords of concrete swam through the streets
like schools of fish with their arms swaying
saluting every structure built to trap them
I watched a wino drag across his iris
with a brown paper bag filled to the brim
with yesterday's mistakes

I saw the white chalk that chalked the white of his eyes
whiter than the lies they told us about him killin himself
I heard your mother said you had too much light for the world
for you to deprive us of its son, We never believed them anyway
Word around town is that you were a comedian, a griot.
one of the many that never plant their feet under
the blinding stage lights of *Saturday Night Live*
Word is you could light a room up.
A walking talking Roman candle
that could burst through the deepest depression
on the darkest night, a reminder to the suicidal neighbor next door
that laughter fills empty hearts far better than apathy ever could

I was told you were somebody, among the other somebodies
that the system failed purposely
another notch under a cruel society's waistbelt
a testimony to why we deserve these very conditions
I was told that your death was a climax
to an American horror film entitled the black body
that your skin made you disposable

I saw the place they built for you and so many others to perish in still standing
but by God, Jericho's walls have begun to fall in the minds of the masses.
"Stay woke" is no less prayer than the monk
who meditates demons away with every chant

I looked Freddie in the eye today
and saw one man who birthed one thousand freedom fighters
I saw a man whose eclipse set fire to an army
so convicted about being unshackled
they would rather taste teargas
than live another hour under oppression
I saw the world gasp as we torched the colonizer's establishments

I saw the world mourn as the colonizer's business interests became piles of soot
I saw the world oblivious to how we who are birthed in the concrete asylum
understand at a cellular level that people like Tyrone West
were murdered far before the enemies of the sun crossed his path

I looked Freddie in the eye today
I saw 9 mm shells bounce off the pits of his eyes
as Keith Davis Jr. prayed to be delivered
from a summer day gone execution.
I saw the suppressed screams of five-year-old Amir
as the agents of evil attempted to snatch the soul of his father Abdul Salaam
I saw sorrow on a Wednesday night in November
rip across the face of Tawanda Jones
only to be followed by a mystic courage
that could only be reserved for the mothers of our universe
I saw your eyes cloud with promise
because a new city had been birthed
in the minds of us who were still here in the physical
I saw your face become colorful
overrun with all hues of people
standing against every atom of what you died for

I looked Freddie in the eye today
I saw a martyr
who fueled a renaissance
assembled a village
and for the child who looks
outside their window
and is again greeted by concrete promises
they too look in his eyes
and what they see is still being determined
and what we know is that this is not the end
and for your murderers
they couldn't have looked in your eyes
or else they would have seen a people willing
to sacrifice everything so that our children
never have to bargain on their knees for their tomorrows again
they would have known that this is not the generation
that waits on moral arcs of the universe to bend
but that we will break and shatter injustice
wherever and whenever we see fit
I looked Freddie in the eye today

Tariq Touré

DEVIN ALLEN

was born and raised in West Baltimore. He gained national attention when his photograph of the Baltimore Uprising was published on the cover of *Time* in May 2015—only the third time the work of an amateur photographer had been featured. His photographs have also appeared in *New York* magazine, the *New York Times*, the *Washington Post*, and *Aperture*, and in the permanent collections of the National Museum of African American History and Culture, the Reginald F. Lewis Museum, and the Studio Museum in Harlem. He is the founder of Through Their Eyes, a youth photography educational program, and the winner of the 2017 Gordon Parks Foundation Fellowship.

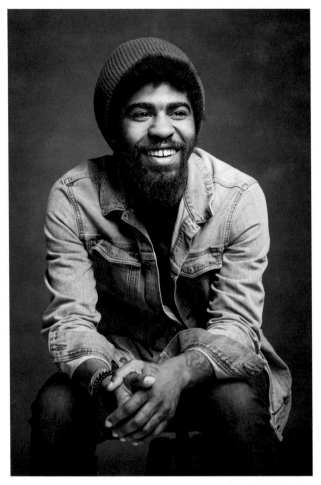

© F. J. Hughes